Street Art
Contemporary Prints

Riikka Kuittinen

V&A Publishing

With huge thanks to Catherine Flood, Frances Rankine and Gill Saunders for their hard work and support.

First published by V&A Publishing, 2010
V&A Publishing
Victoria and Albert Museum
South Kensington
London SW7 2RL

Distributed in North America by Harry N. Abrams, Inc., New York

ISBN 978 1 85177 625 2
Library of Congress Control Number 2010933069

10 9 8 7 6 5 4 3 2
2014 2013 2012 2011

A catalogue record for this book is available from the British Library.

All dimensions are given as height by width.

Designed by Peter & Paul
Copy-edited by Philippa Baker

Jacket: Kerry Roper, *Time Waits for No Man* (p.72)
Page 2: D*Face, Detail from *Feels So Good* (p.57)
Page 4: Banksy, Detail from *Napalm* (pp.22–3)
Page 92: The Krah, Detail from *The Krah* (p.70)

Printed in China

V&A Publishing
Victoria and Albert Museum
South Kensington
London SW7 2RL
www.vandabooks.com

Contents

A New Art Form

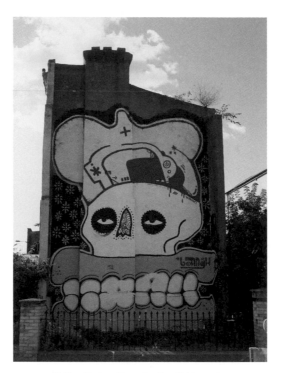

Sickboy/Cyclops/Sweet Toof, graffiti in London
Courtesy of Art of the State

Our built environment is increasingly covered with images. Sprayed stencils, stickers, paintings and doodles are everywhere, embellishing the city. Graffiti has evolved into a rich and democratic visual expression that we now call 'street art'. As it matures as an art form, street art takes shape in a variety of techniques, from printmaking to painting. It is characterized less by a visual style than by an approach to transmission: it is unfiltered visual communication, fluidly moving across the derelict buildings, bus shelters and hoardings of cities across the world. Street art is a new genre, and street-art prints, as collected by the Victoria and Albert Museum, are a new development for printmaking. Although street artists experiment with different media and subject matter, elements of street art can be traced back to more traditional art forms. References and symbols run through the street-art story: images range from pop culture to politics and from self-promotion to art history; spiky comments on the state of the world sit alongside images of forgotten celebrities, expressing an attitude of irreverence, equality and freedom without a common aesthetic.

The V&A has been collecting street-art prints and multiples by established names and emerging artists since 2004. The collection is international, with British, French, Brazilian and American artists represented. The acquisition of these works continues and enhances the museum's tradition of collecting ephemera, prints and posters. It can also be seen as an attempt to capture an essentially elusive genre that has a strong influence on mainstream graphic design. Advertising, for example, has wasted no time in appropriating the language of street stencils, plundering underground visuals in an effort to appeal to young or youthful consumers. Street art is contemporary, popular and undeniably influential. It echoes the general mood for DIY, which manifests itself in the creative use of modern media within fashion, music, craft and writing.

Wanting to leave a mark on your surroundings is instinctive: think of cave paintings or children with their crayons who impulsively head for the nearest wall. The origins of modern street art can be traced to New York in the 1960s and 1970s, when graffiti artists began tagging or 'bombing' – painting their names and slogans either in a quick scribble or in elaborate calligraphy on communal sites. This mode of publicly expressing opinion has also been put to use by various subcultures: music fans demonstrate their particular enthusiasms ('Clapton is God'); political factions scrawl their comments; football supporters mark their territory; and counterculture movements announce their existence and rivalries.

The artists featured in this book use varying methods of image-making, ranging from simple stencilling to digitally printed stickers. Printmaking is traditionally defined as the application of an image to paper through a mechanical process. This application can be achieved in many ways, and the most common media for transferring pigment to paper include a cut wood block, an incised metal plate or a stone. Prints are usually produced in multiples. Perhaps the most common printing technique used by street artists is screen printing, where ink is applied to a fabric screen bearing a stencilled image, which is then transferred on to paper. Stencil prints are produced by cutting an image into card and then applying paint in the spaces around this template. Digital printing, which is developing rapidly and becoming increasingly accessible, is used particularly in sticker production. All of these methods are grouped together under the heading 'printmaking', and there are examples of each in this book.

Most street artists, whether writing their name in recognizable tags or using a particular image as a symbol, want to mark their presence and share their ideas. The print is an affordable and democratic medium, allowing for endless creative possibilities. While large-scale graffiti painting is a complex process, requiring spray cans with a range of nozzles to achieve a three-dimensional effect, stencil prints can be produced using just one type of spray can. Stickers are portable artworks that can be easily applied anywhere. It is no coincidence that the escalators of the London Underground are a popular site for street-art stickers:

this is probably the only artistic intervention that it is possible to realize on a moving escalator. Stickers operate like small travelling artworks and stencils make the whole city a potential printed surface.

The French artist Blek Le Rat, who began his career on the streets of Paris in the early 1980s, is credited with popularizing figurative stencil work, having been inspired by a stencil of Benito Mussolini he saw in Italy as a child. He uses a cut-out stencil technique – a method also used by Banksy and Miss Tic among others – to create skilfully detailed three-dimensional figures that emerge from the wall like ghostly apparitions. Stencils can be applied either directly to a wall or on to paper that is then pasted to the wall – Blek uses both processes – and produces work with an immediacy and practicality not offered by other methods of wall painting.

––––––––

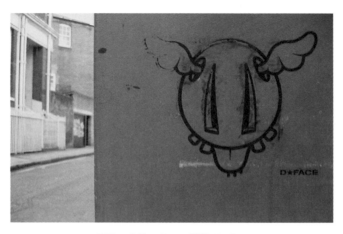

D*Face, Balloon Dog graffiti in London
Courtesy of Art of the State

––––––––

Street-art prints provide a permanent record, freed from any geographical location or painting surface. They challenge the conventional power relationship between painting and printmaking. Typically, prints have been the more ephemeral and disposable objects, often serving as reproductions rather than as artworks in their own right. However, street artworks that are painted on walls eventually get lost to overpainting, the weather or building works, so the print is more permanent. Printed on paper, an image that would otherwise be lost can be kept forever.

As street art and its stars become more established, it has moved indoors, from ephemera to permanence. Galleries and auction houses are now exhibiting and selling street art, creating a primary and secondary art market for a genre that is essentially defined by its outsider status. Street-art prints have played an important part in this process, since, unlike *in situ* wall paintings, they allow ownership. (Of course, enterprising street-art fans occasionally simply remove whole sections of wall if an artwork takes their fancy.) These prints often reproduce wall paintings, using the same stencils that created outdoor artworks. Art made outdoors has transcended the gallery–street boundary before, most famously in the work of American artists Jean-Michel Basquiat and Keith Haring in the 1980s. Basquiat moved from graffiti to fine art, showing in galleries in New York and collaborating with Andy Warhol, and Keith Haring's graphic, colourful style is a strong influence on twenty-first-century street artists. But contemporary street artists, even after gaining recognition and selling through galleries, tend to reserve the right to produce street work, not crossing fully into the gallery but keeping one foot outside.

Perhaps one of the elements separating street art from contemporary art – even in the context of galleries and auctions – is the priority of image over concept, the visual over the idea. The genre has certainly produced interesting and accessible imagery and its visual one-liners have captured the imagination of the audience, Banksy's work being a notable example.

The more figurative, less wordy style of contemporary street art, different from graffiti based on writing, offers possibilities for exploring the old within the new. Before the invention of photography, prints were a mass-produced visual communication tool for disseminating pictures of royalty, the latest furniture and fashion styles or records of current issues or events. Now this medium is explored by young artists, who use it to communicate either socio-politically relevant or purely visual messages.

City streets have traditionally been the site of spray-painted political commentary. At its most basic, the scribbled opinion has relied on a visible location and a quick turn of phrase: 'Hands up who voted Tory' in London in the 1980s, or 'Under the paving stones: the beach' – slogan of the student uprisings of 1968, presumably coined as the demonstrators ripped up street paving to hurl at the police. Stencils are particularly well-suited to spreading a politically loaded message. The image can be both produced and interpreted quickly, unhindered by language barriers. Using familiar imagery, street artists rely on our ability to decode what we see. Banksy in *Napalm* (pp.22–3) and Jamie Hewlett in *Big Spongefinger* (pp.26–7) comment on recent conflicts by using images of the Vietnam War. It seems that late twentieth and early twenty-first-century wars have created few iconic images, perhaps because of the huge volume of visuals produced by news on TV and the web. An interesting exception to this is the

instantly recognizable image of an Iraqi prisoner hooded and tortured in Abu Ghraib Prison. It has entered the contemporary visual lexicon and become so familiar that it has been reproduced in stencils in Italy and France by simply using the silhouette of the prisoner (below).

———————

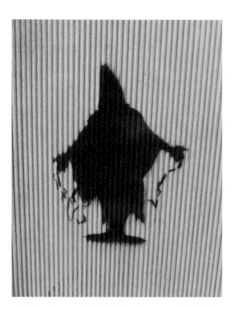

Artist unknown, Abu Ghraib prisoner stencil in Paris
Photograph by Duncan Cumming

———————

The way street artists rely on our collective ability to interpret images demonstrates, almost accidentally, an inescapable element of contemporary life: our reliance on the visual. We hold image banks in our heads and act like visual theorists. We are bombarded by images all day, everywhere, and street artists have become skilful in demanding our attention in the cluttered urban landscape. Now a culture of actively seeking out street artworks has emerged, with fans taking street-art walks detailed in street-art city guides. However, for most of us, street art provides the thrill of accidental discovery and unexpected points of view.

Although physically street art is of its location, the genre is made international by the Internet. It is archived by an energetic and international network of peers on websites and in magazines. On the Internet, street art transcends geography: the latest Banksy stencil can be seen anywhere in an instant. The Internet documents images, blogs and exhibitions, holding on to works long gone.

In the tags of the writing-based graffiti that peaked in 1970s New York, graffiti writers took one element of traditional painting – the artist's mark – and made that into the artwork, discarding everything else and emphasizing authenticity. After all, it is the signature of a painting that proves its provenance. Particular recognition was given to those creating works in daring circumstances, New York subway trains being the classic example of a travelling artwork. Graffitied trains are so recognizable in our consciousness that they have become shorthand for an urban context, forever used as cinema and music-video backdrops. The more daring the location and colourful and impressive the piece, the more admiration and status the artist gained. This compulsion for recognition-seeking also exists within figurative street art. Contemporary street artists create logos for themselves, repeating their chosen visual motif in their work. A symbol can be anything from grimacing dentures to forgotten celebrities, as long as it is simple, easily reproduced and malleable. The viewers are trusted with the ability to spot the emblems, whether they are shown as part of a larger image or alone. Once a symbol is established, it can make an appearance anywhere.

Shepard Fairey uses the face of André the Giant – a French-born show wrestler and actor who died in 1993 – his visage often accompanied by the staggering proportions of his enormous physique. The campaign began life as *André the Giant has a Posse* in the late 1980s, and André's face has been spreading through stickers, stencils and prints ever since (pp.42–5). The *Obey Giant* project, perhaps the best-known symbol-led street art in existence, is a cult created out of nothing. *Obey* has spread internationally, aided by other image-makers copying the image, freely appropriating another artist's work. Fairey's style nods towards early Soviet-era Russian Constructivism (p.12) and the visual innovations of Alexander Rodchenko, this Communist reference giving an ironic dimension to Fairey's unofficial Barack Obama *Hope* poster campaign in 2008. *Obey Giant* could be described as a conceptual experiment in viral communications, spreading an essentially meaningless image.

The use of celebrity faces, also seen in the work of ESM-Artificial (p.55), owes an enormous debt to the usual suspect: Andy Warhol. His presence is immeasurable in contemporary art, and his screen-printed multiples are an obvious reference for many street artists. Image-led street art would probably not exist if it were not for Warhol's celebration of the mundane and the meaningless, conceptualizing the famous face as an everyday object.

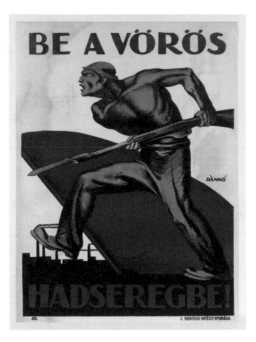

Ödön Dankó, *Be a Vörös Hadseregbe!* (*Join the Red Army!*)
Lithograph poster, 126.2 × 93.6 cm. Hungary, 1919
V&A: E.1289–2004
Gift of the American Friends of the V&A;
Gift to the American Friends by Leslie,
Judith and Gabri Schreyer and Alice Schreyer Batko

Rather than trademarking their work with a repetitive visual motif, some artists look to art history, contemporary culture and other image-makers to create something of their own. By using visual language typical of another art genre – as, for example, in Meggs' *Save Me (From Myself)* (p.60) – they create a world that is new but recognizable. Twenty-first-century street artists use any visual language that takes their fancy – a Babel's Tower of images. Street art may be influential, but it is also influenced. This democratic appropriation of references can be detected in the work of Banksy and his cut-and-paste approach to any image, familiar or sinister (pp.21–4), or in the joyous dressing-up-box plundering of the past seen in the work of Pure Evil (pp.28–31). Even Eadweard Muybridge's sequential photographs of figures in motion have made an appearance as a street stencil in London. This makes street art a discourse of multiple voices, fusing the contemporary with the established: layers of meaning coexist like a wall peeling with scraps of posters and paint. References to art history are taken to their logical conclusion in the trend for framing prints in elaborate Baroque-style gilded frames – a jolly two-finger salute to the divide between the establishment and the street.

One recurring theme drawn from the canon of art history is memento mori ('remember you must die'), specifically the *vanitas* still-life representing the hollowness and brevity of human life, often in the motif of a skull. A number of artists such as Fefe Talavera, Nomad and Sweet Toof use the skull as a recurring emblem. Fefe Talavera's *Jugando con la muerte (Playing with Death*; p. 63) echoes the South American Day of the Dead tradition, with which the memento mori genre is associated. The 'Dance of Death' theme popular in medieval religious books and church frescoes shows skeletons dancing with people from all walks of life as a reminder of our collective mortality. In *Jugando con la muerte*, the skull appears to be having a boogie with Talavera's own lizard symbol. Street artists approach the universal subject of mortality in their own irreverent way.

————

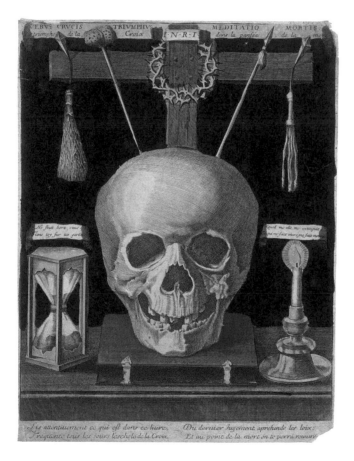

Artist unknown, *Verus Crucis Triumphus Meditatio Mortis*
Hand-coloured engraving, 41.5 × 32 cm. France, late 17th century
V&A: E.31—1987

————

The influence of Surrealism can be detected in street artists' use of random visual combinations and their questioning of the established order of seeing things. This is often achieved through character creation. Jon Burgerman conceives villages full of oddly shaped creatures with elongated limbs (pp.66–9), and *Discípulo da Luz* by Alex Hornest (p.76) depicts an unsettling creature, a spirit emerging like a puff of opium smoke. Although offering an immediate visual impact, these characters demand further inspection, rewarding a closer look into their intricate detail. Burgerman's illustrated patterns bring to mind engraved grotesques, where leaves interweave with mythical figures such as satyrs, all layered into a surreal wallpaper of imagery (below).

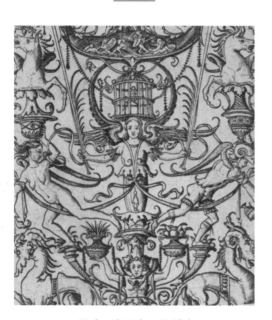

Nicoletto da Modena, Untitled
Engraving, 26 × 13 cm. Italy, c.1500—12
V&A: E.180—1885

Street artists also embrace the opportunities offered by more established, painterly methods of image-making. This can be seen in the work of Graeme Nimmo and Best Ever: not traditional painting but painting evolved. Graeme Nimmo's work echoes portraiture and nudes in particular – classic subjects newly represented (pp.86–7). We think of street art as moving from gritty outdoor streets to pristine indoor galleries, but maybe it works the other way around too: the paintings and portraits in museums jump off their frames and bleed into the walls outside.

There is a performative aspect to street art. Jackson Pollock-style painterly action, with physicality built into the artwork, is echoed in the stunts performed by street artists in the creation of their work, climbing on to roofs and railway bridges. The viewers see not the performance, only its remains. A kind of secret or a reverse performance takes place – an interventionist act that we bear witness to after the event.

Street artists not only spar with each other in an effort to create exciting imagery in unusual locations, but are also in an ongoing discourse with their environment, changing and highlighting the surrounding space. The best street art uses its surroundings as a springboard to create a memorable visual. Eine's giant individual letters, painted on shop shutters so they appear only in the evening, are an example of this kind of transformative intervention (below). It is simple and surprising and visually straightforward in its enjoyment of colourful typography.

———

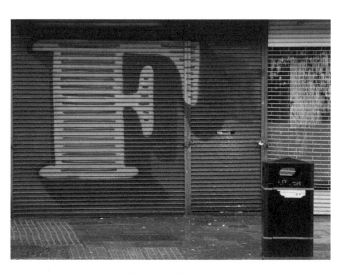

Eine, Letter F in London
Courtesy of Art of the State

———

Street art would not be street art in a rural setting, and perhaps the countryside has no need for extra visual embellishment. Street art has the ability to question the familiar by adding an unexpected element to the city landscape. Effectively, it has the power to reframe the mundane.

A form of self-censorship is utilized by street artists when selecting locations for their work. Hoardings, disused buildings and advertising boards are used as canvas or printing surface much more often than buildings that hold more value. Street artists add aesthetic interest to disused public space. Arguably, a stencil work on a wall is free public art. This renegade act of kindness in creating art on the street undermines ownership: the work belongs to no one and everyone by default.

The mere existence of street art encourages passers-by to experience their environment not just in a better way, but at all. Visitors to galleries and museums arrive searching for something to look at, expecting a particular experience. In contrast, street art often confronts us unexpectedly. It questions the way the city is used and seen and the way we live in it.

Whatever street artists do inside gallery walls or in permanent museum collections that are packed away in cloth-covered boxes and stacked up in environmentally controlled storage – the defining feature is the city. Galleries cannot claim to have exclusivity over an artist if he or she still shows on the street. Street art retains an element of bypassing commerciality, giving artists freedom of expression. Without the city and its artists, prepared to comment on issues and take risks, this genre would not exist. It is the most urban of art forms and perhaps the most modern. As an art form, it is evolving and reaching maturity. And undeniably it is an art form.

→
Dscreet
Detail from
Black and White Owls (12/50)
Screen print
70 x 50 cm, 2008
V&A: E.327—2010

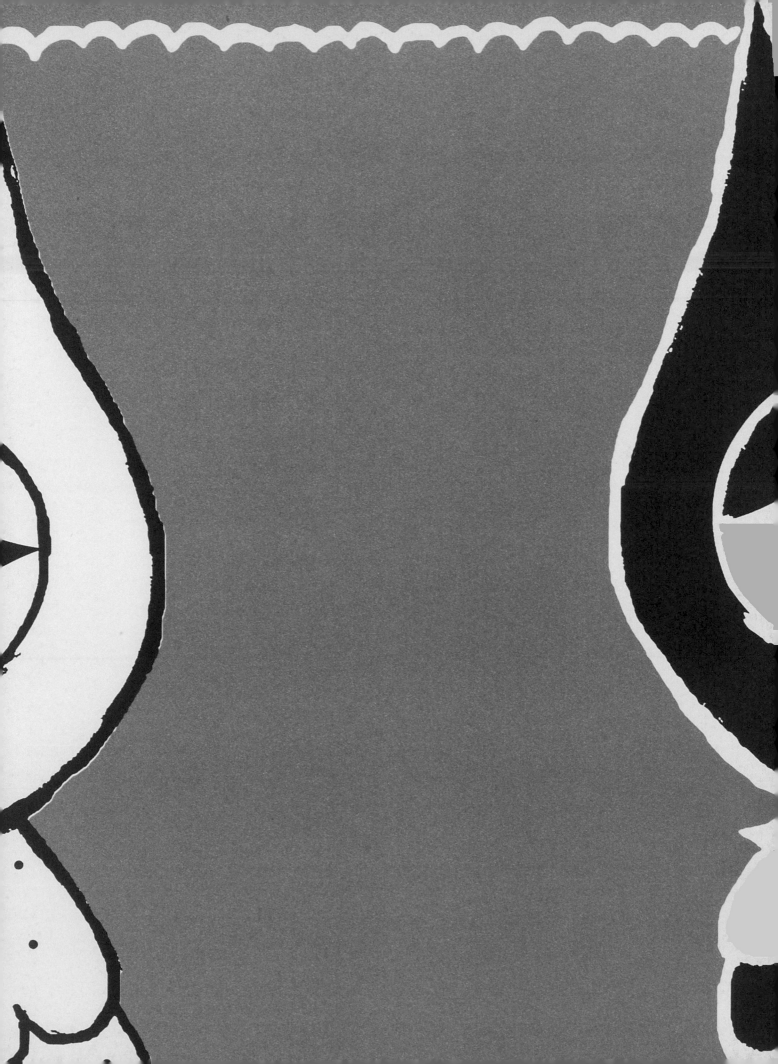

Politics
and
Propaganda

Street art has its roots in political commentary, from propaganda posters to spray-painted slogans. Stencils in particular have been utilized in political struggles: for example, Benito Mussolini's recognizable face stencilled on the streets of Italy served as shorthand for his policies, as witnessed in the 1970s by the young Blek Le Rat, who was later inspired to try out the technique for himself (p.34). Much of the V&A's street-art collection focuses on socio-political commentary. Artists such as Banksy and Scorn combine familiar imagery and references in collages of visual information that address current world events. Themes include war, politics, religion and our reliance on technology. Street artists also specialize in more optimistic propaganda, as seen in Pure Evil's *Your Heart is a Weapon the Size of Your Fist* (pp.28–9).

Banksy
Virgin Mary (23/600)
Screen print
69.6 × 49.7 cm, c.2004
V&A: E.385—2005

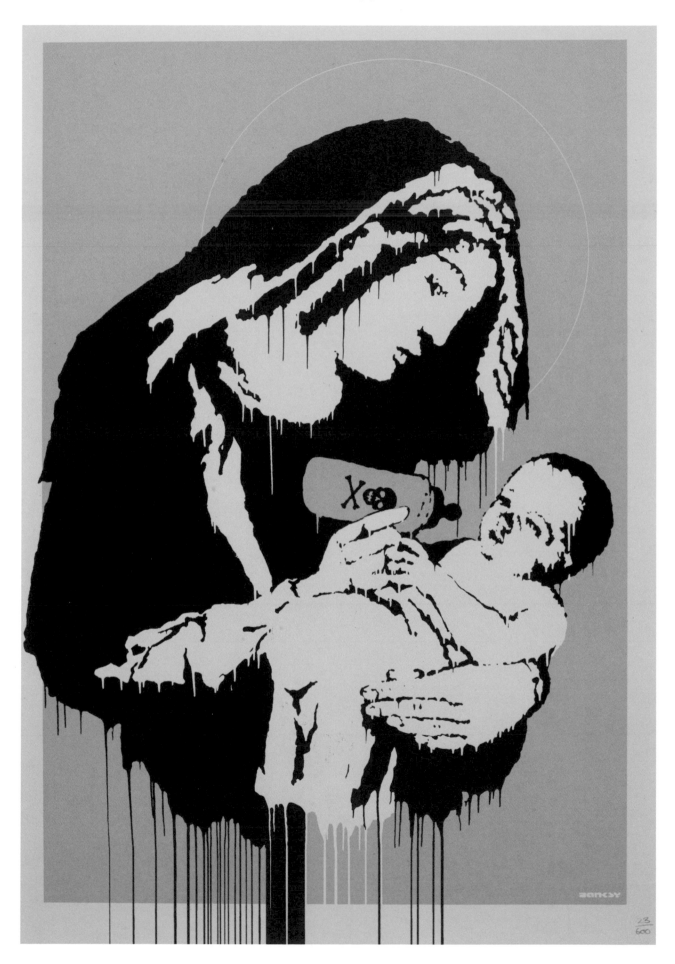

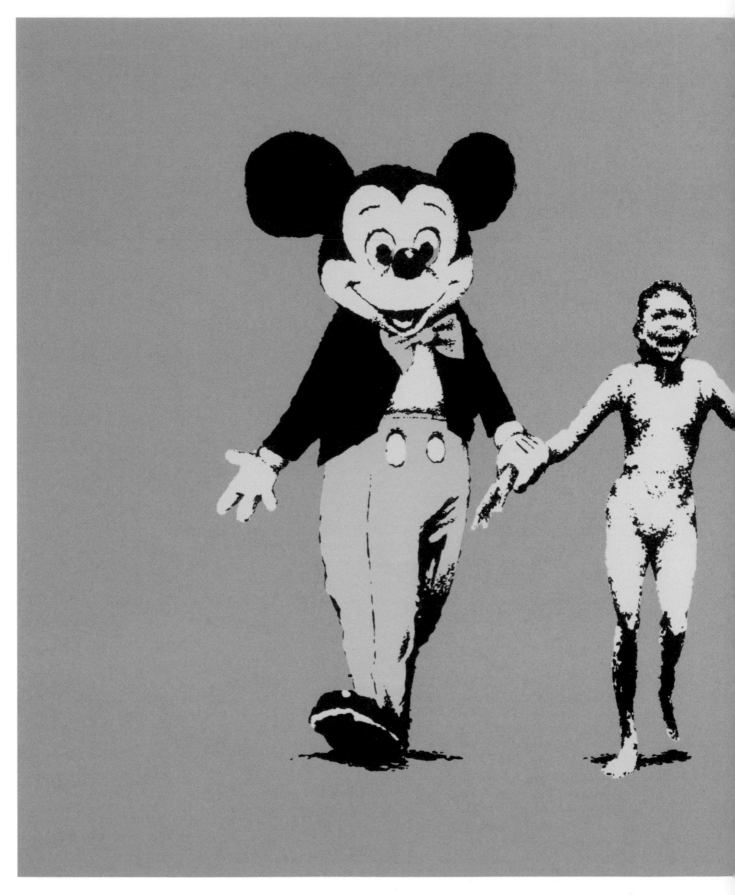

Banksy, *Napalm* **(101/500)**
Screen print
49.2 × 69.8 cm, c.2004
V&A: E.386—2005

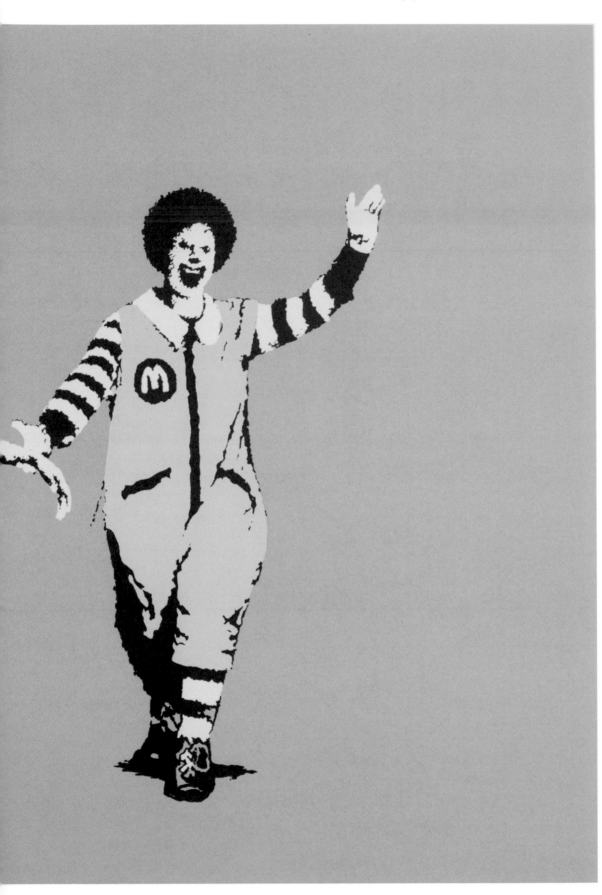

THE HENLEY COLLEGE LIBRARY

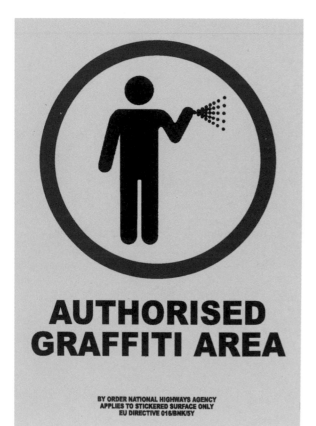

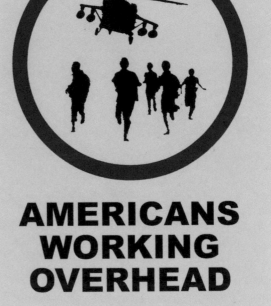

↑
Banksy
Authorised Graffiti Area
Sticker
15 × 10.4 cm, c.2004
V&A: E.390—2005

↑
Banksy
Americans Working Overhead
Sticker
15 × 10.3 cm, c.2004
V&A: E.388—2005

→
Scorn
Death Tarot Card (4/77)
Screen print
77.7 × 46 cm, c.2009
V&A: E.322—2010

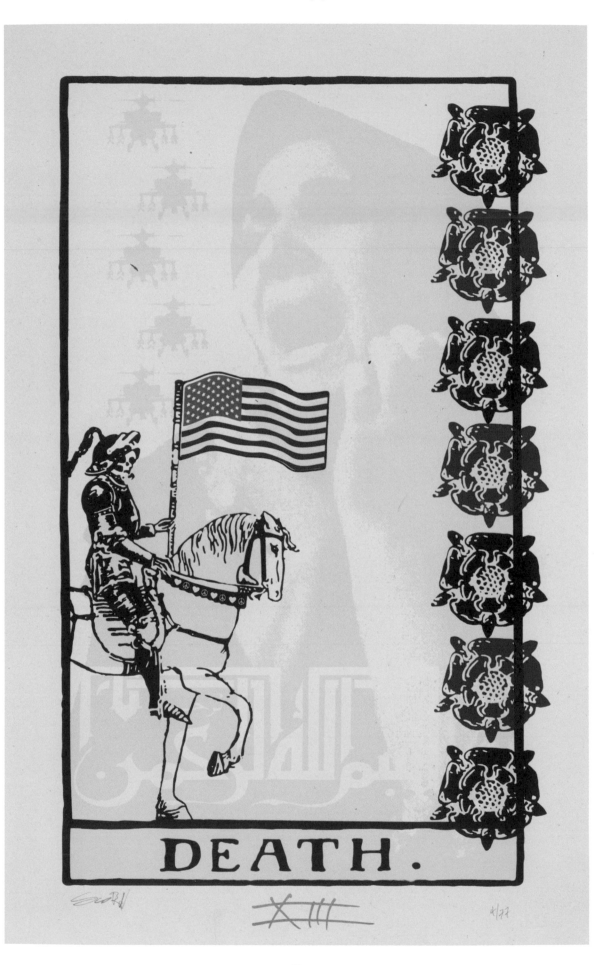

DEATH.

Jamie Hewlett
Big Spongefinger (46/600)
Screen print
34.5 × 69.7 cm, c.2004
V&A: E.387—2005

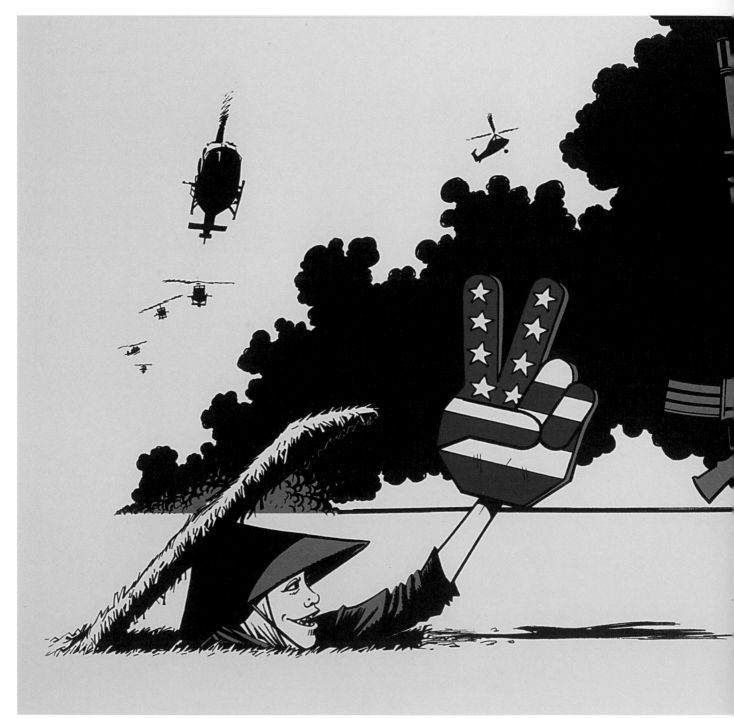

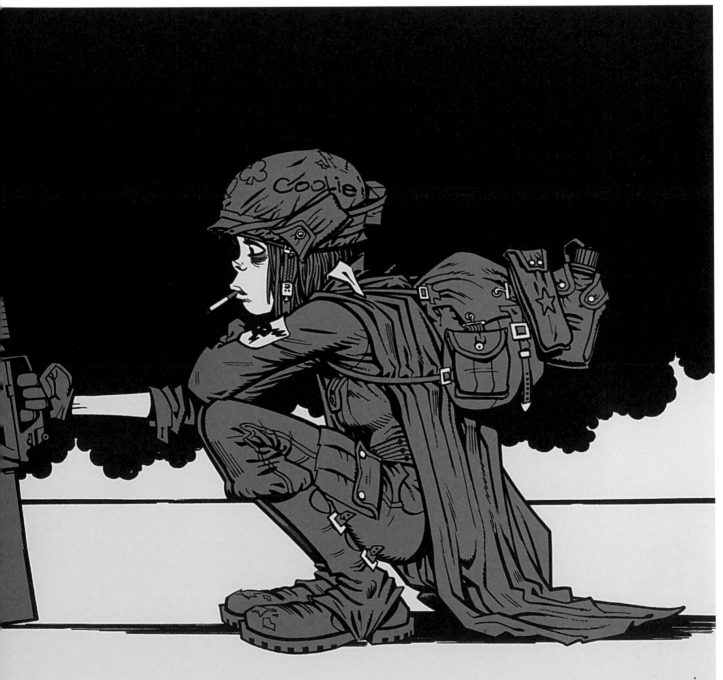

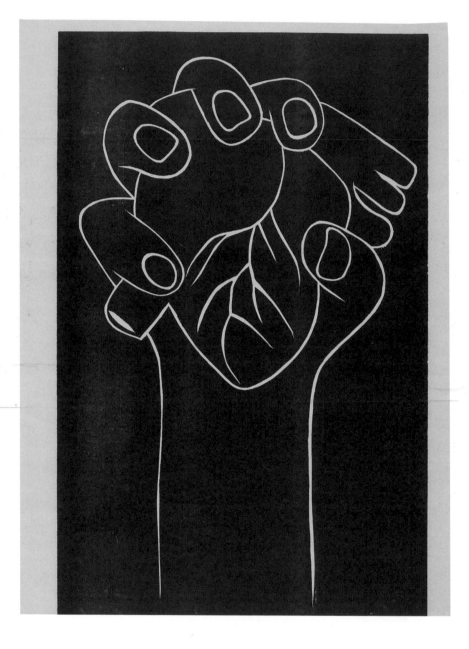

Pure Evil
Your Heart is a Weapon the Size of Your Fist
Woodcut on paper, 66.3 × 48.9 cm, 2009
V&A: E.488:1–2009
Gift of the Pure Evil Gallery

Pure Evil
Your Heart is a Weapon the Size of Your Fist
Woodcut on paper, 66.3 × 48.3 cm, 2009
V&A: E.488:2—2009
Gift of the Pure Evil Gallery

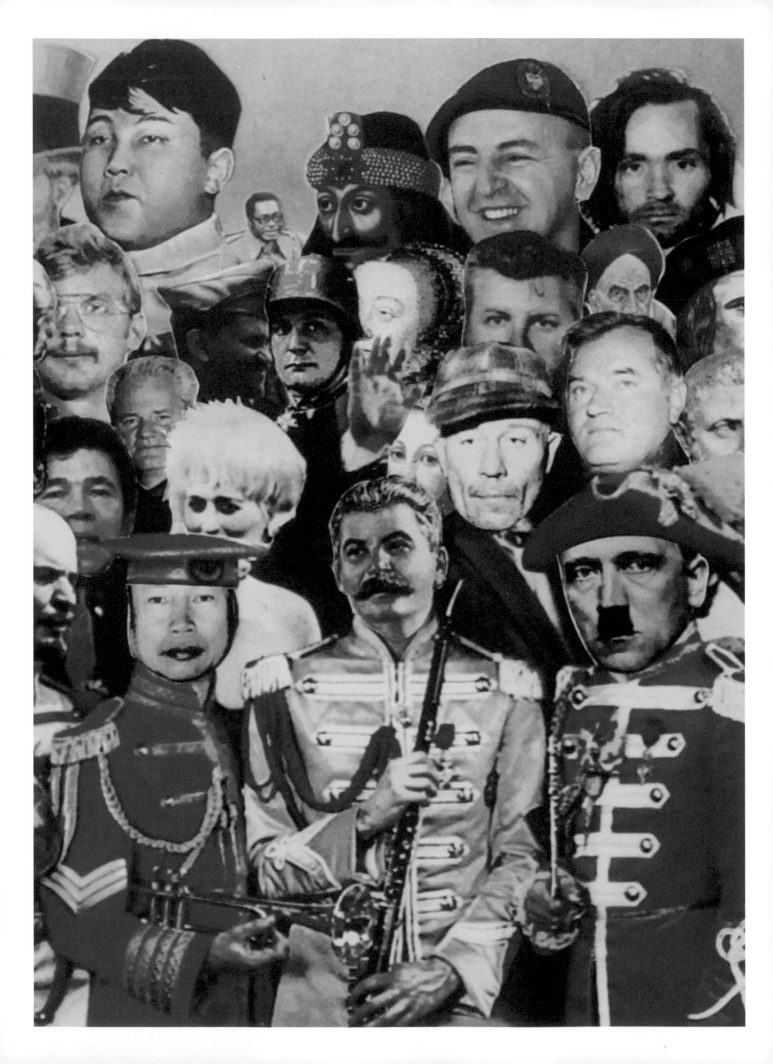

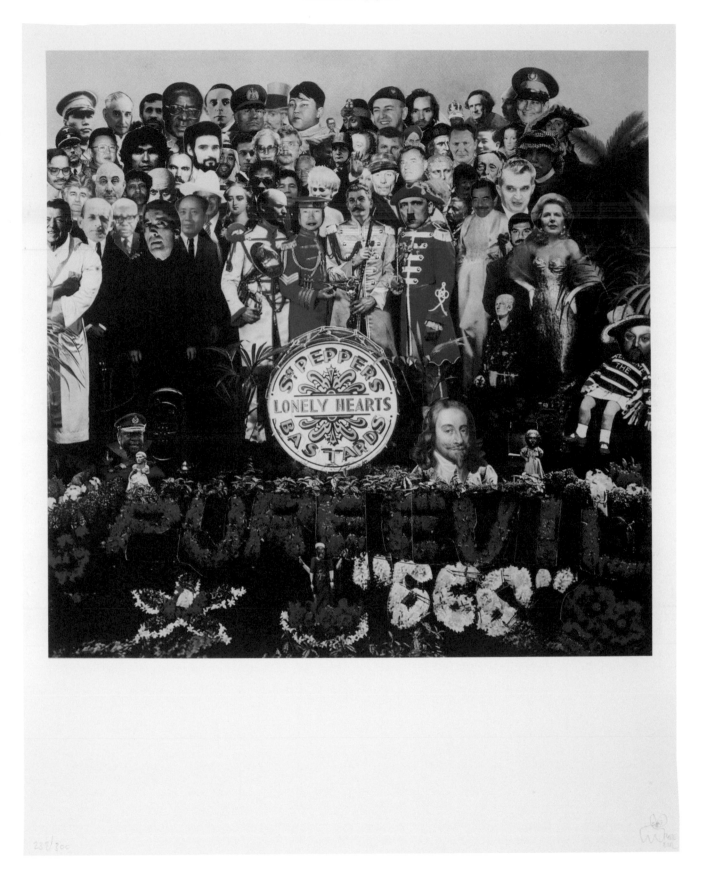

Pure Evil, *Sergeant Pepper's Lonely Hearts Bastards* (238/300)
Screen print, 69.5 × 55 cm, c.2008
V&A: E.490—2009
Gift of the Pure Evil Gallery

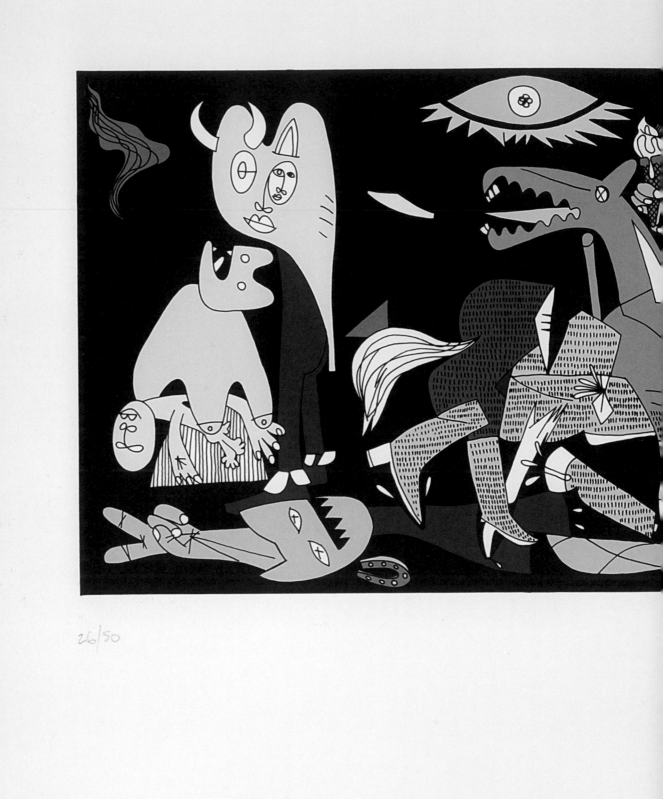

26/50

Pablo Picachu (Pure Evil), *Guernica* **(26/50)**
Screen print, 36.7 × 60 cm, 2007
V&A: E.491—2009
Gift of the Pure Evil Gallery

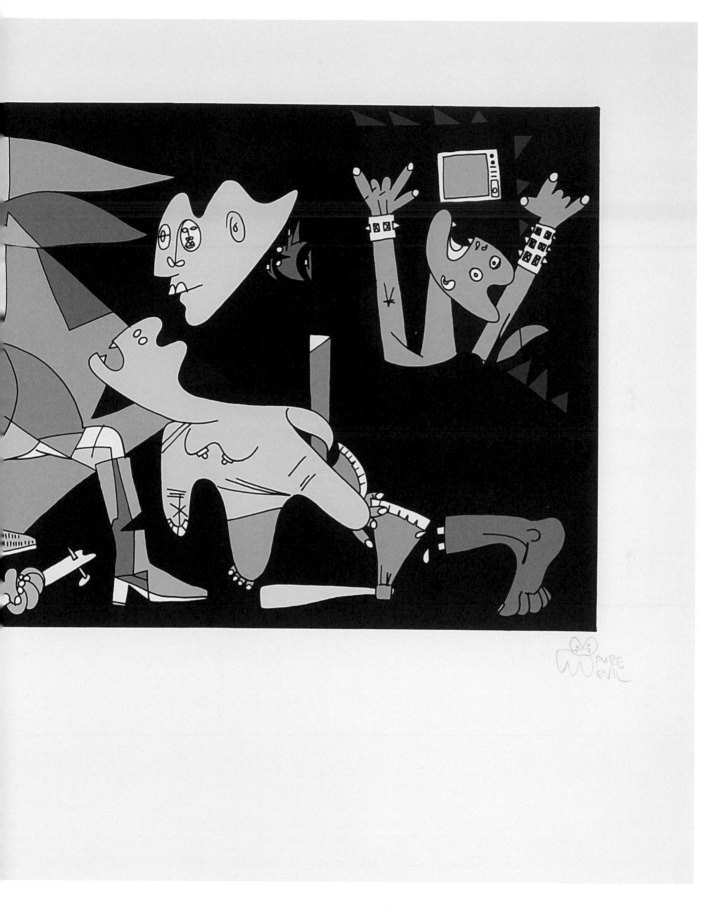

→
Kerry Roper
Modern Youth
Inkjet print
59 × 42 cm, c.2009
V&A: E.326—2010

↓
Blek Le Rat
Computer Man (139/140)
Screen print
74 × 72 cm, c.2009
V&A: E.323—2010

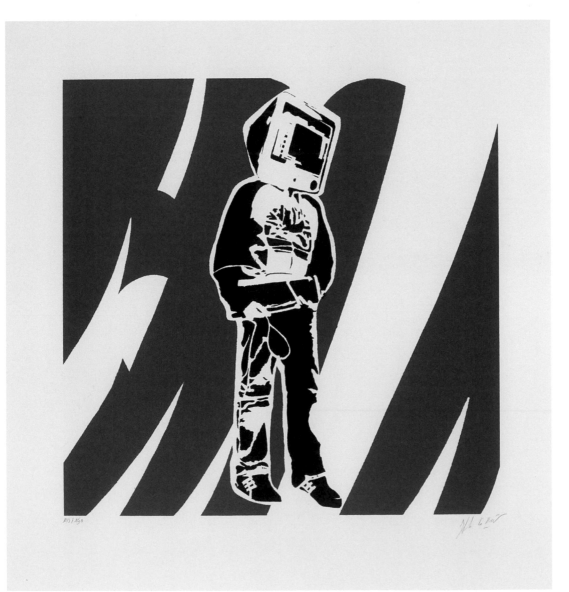

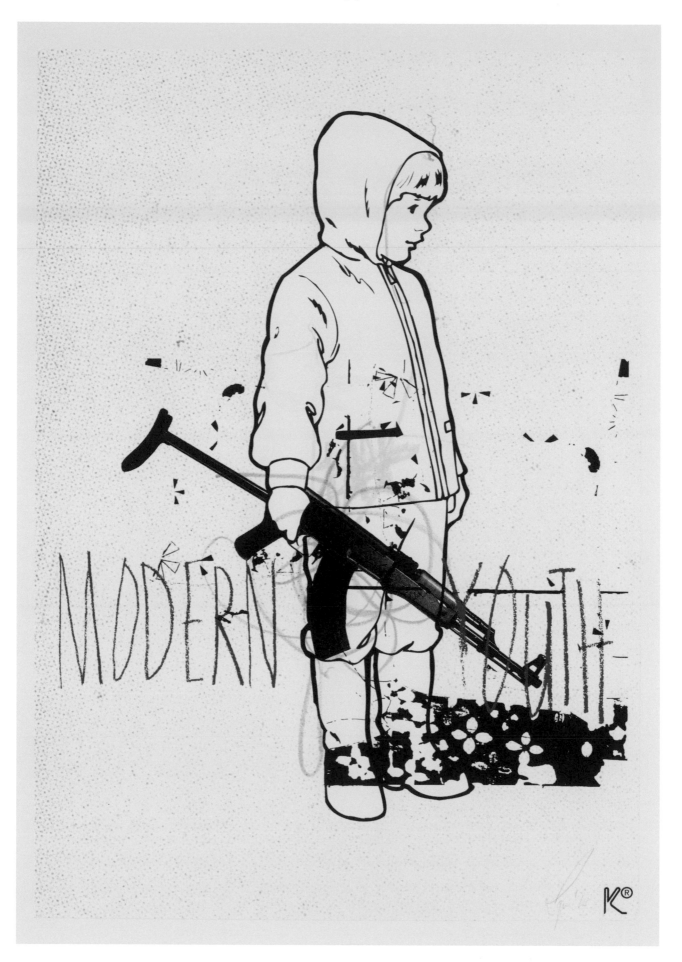

→
3-D
In Europe (194/600)
Screen print
70 × 50 cm, c.2004
V&A: E.384—2005
Purchased through
the Julie and Robert
Breckman Print Fund

↓
Blu
Gaza Strip (35/100)
Screen print
90 × 55 cm, c.2009
V&A: E.335—2010

←
Eine
Detail from *Scary* (101/200)
Hand-pulled screen print
30 × 80 cm, 2008
V&A: E.319—2010

Symbols
and
Characters

Most street artists create a symbol for themselves, much like graffiti tags. These symbols can appear on their own on the streets or be combined with other imagery. With time and repetition, such symbols become a kind of visual shorthand for their makers: Dscreet is known for owls, Pure Evil for evil bunnies, D*Face for angel wings, Sweet Toof for teeth, and so on. D*Face sticks his cartoonish angel wings on Superman (p.57), while Shepard Fairey's Obey Giant series (pp.42–5) has made a symbol out of a show wrestler. With a repeated motif, there is no need for a signature. The artist's logo operates as a kind of heraldic device, taking the form of a spray-painted image instead of a signet ring pushed into molten wax.

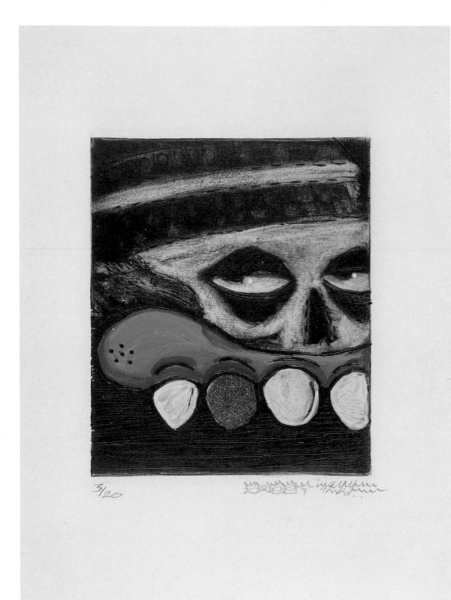

↑
Sweet Toof
Untitled (3/20)
Etching, dry point
in zinc, hand coloured
29.5 × 21 cm, 2009
V&A: E.431—2009

→
Sweet Toof
Pearly Whites (3/35)
Screen print
49.5 × 34.4 cm, 2008
V&A: E.432—2009

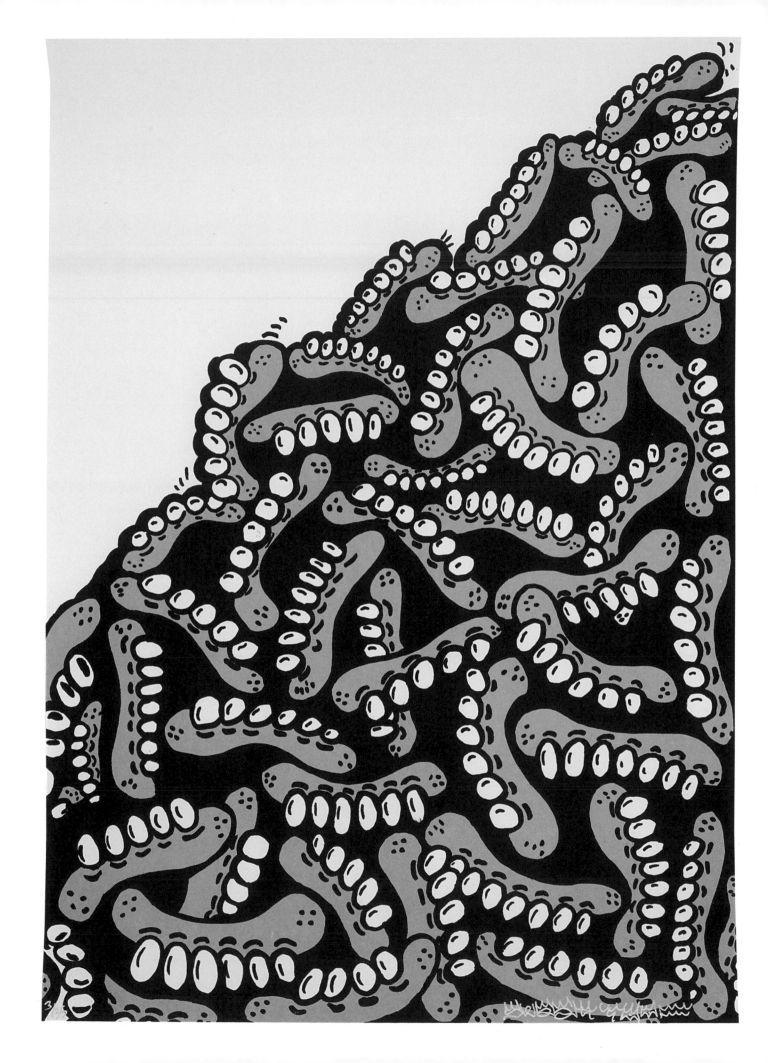

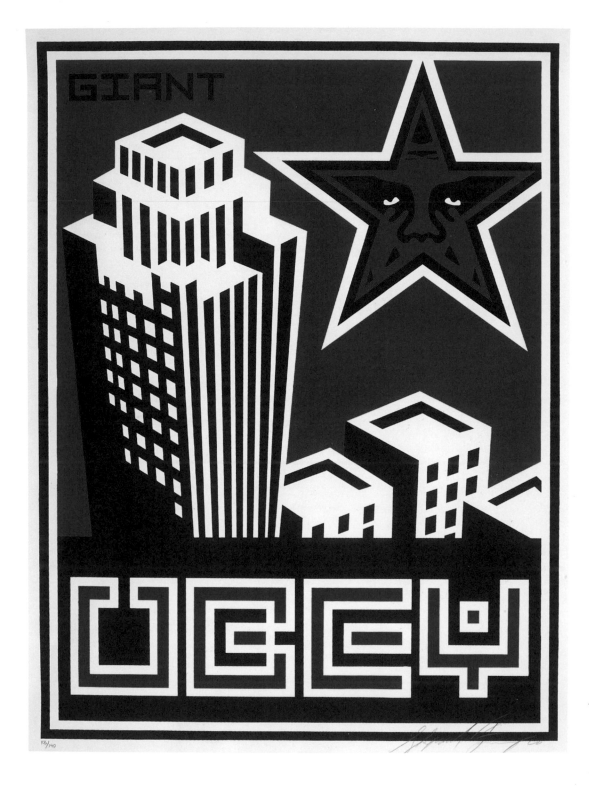

Shepard Fairey
Obey Skyline (103/140)
Screen print
60.7 × 45.6 cm, 1999
V&A: E.363–2006

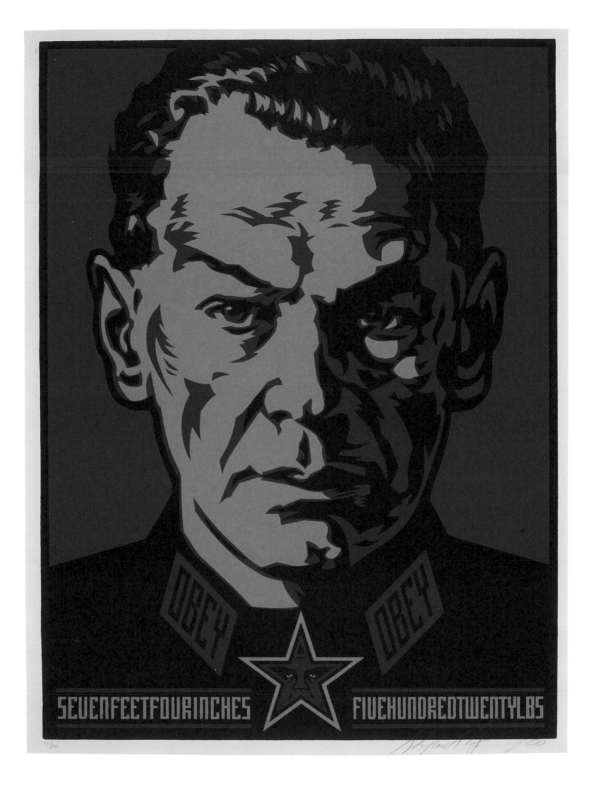

Shepard Fairey
Authoritarian (30/140)
Screen print
60.7 × 45.6 cm, 2000
V&A: E.363—2006

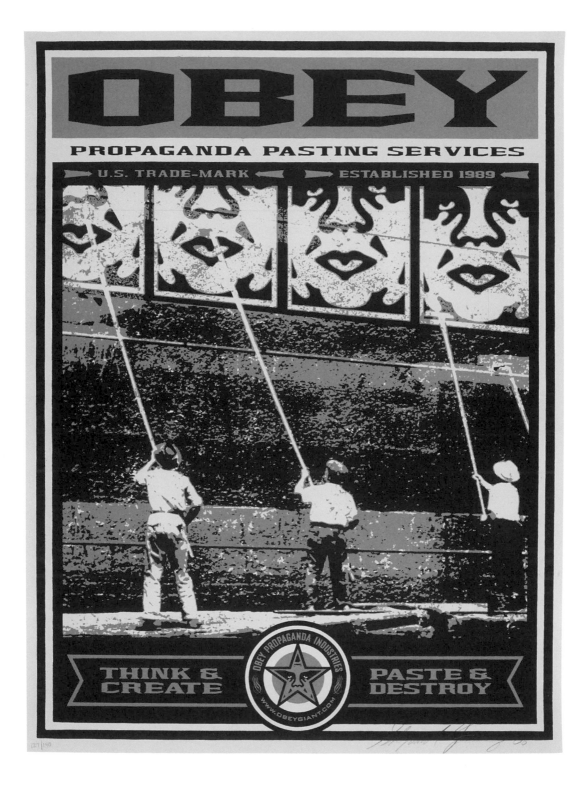

Shepard Fairey
Old School Pasters (127/140)
Screen print
61 × 45.8 cm, 2001
V&A: E.364—2006

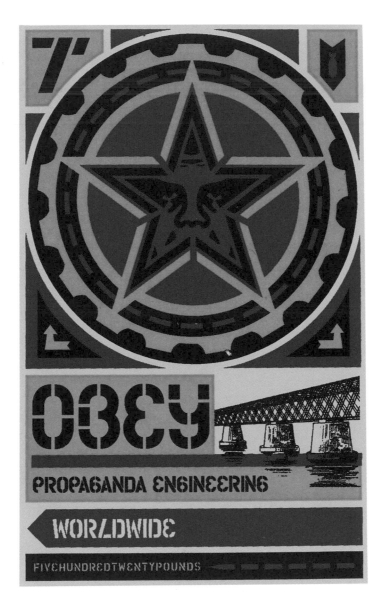

Shepard Fairey
Obey Engineering
Sticker
9.5 × 6 cm, 2000
V&A: E.316—2005

Dscreet
Black and White Owls (12/50)
Screen print
70 × 50 cm, 2008
V&A: E.327–2010

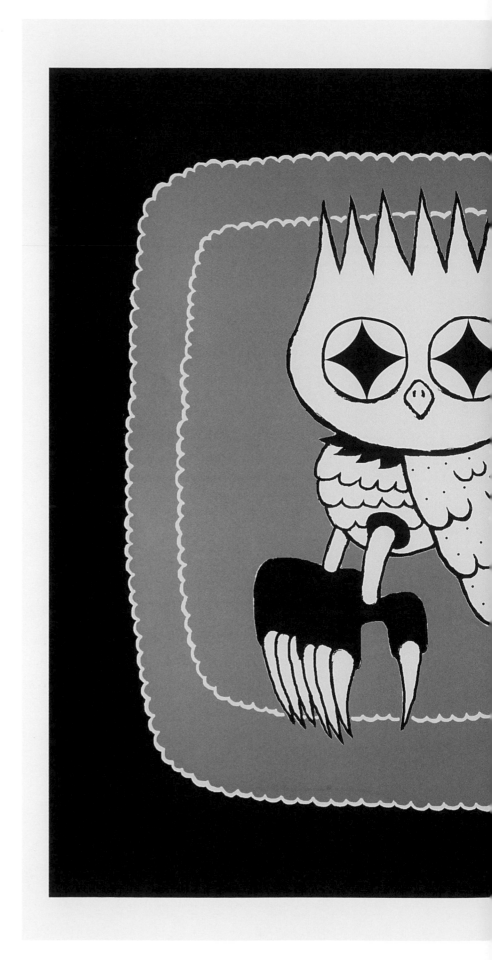

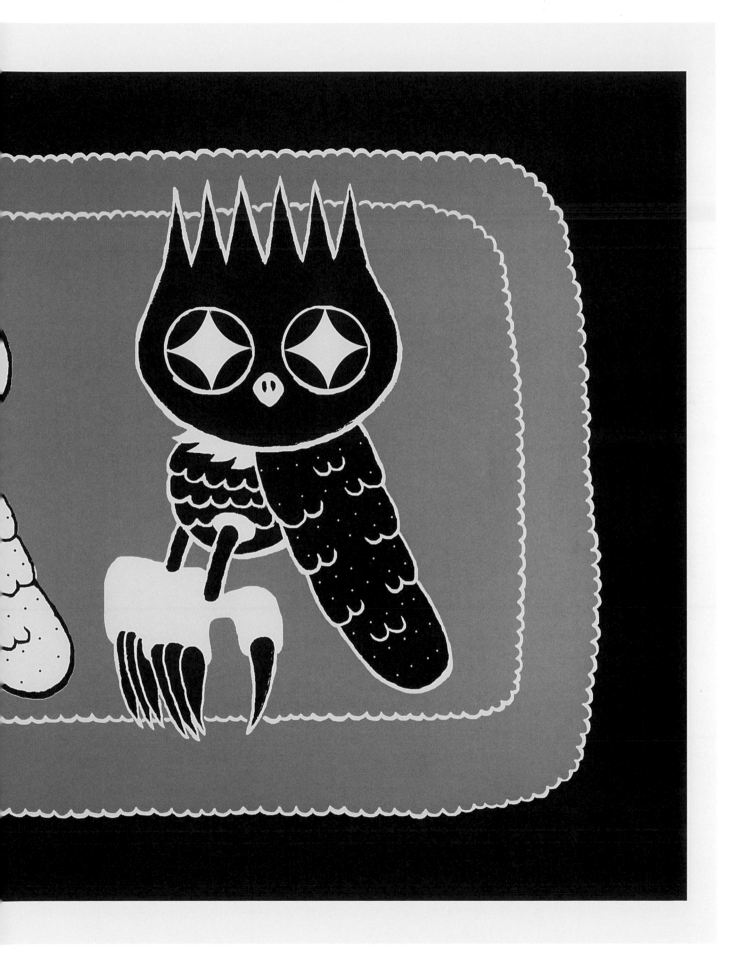

Nomad
Skull Bunny (22/75)
Screen print
55 × 55 cm, 2009
V&A: E.336–2010

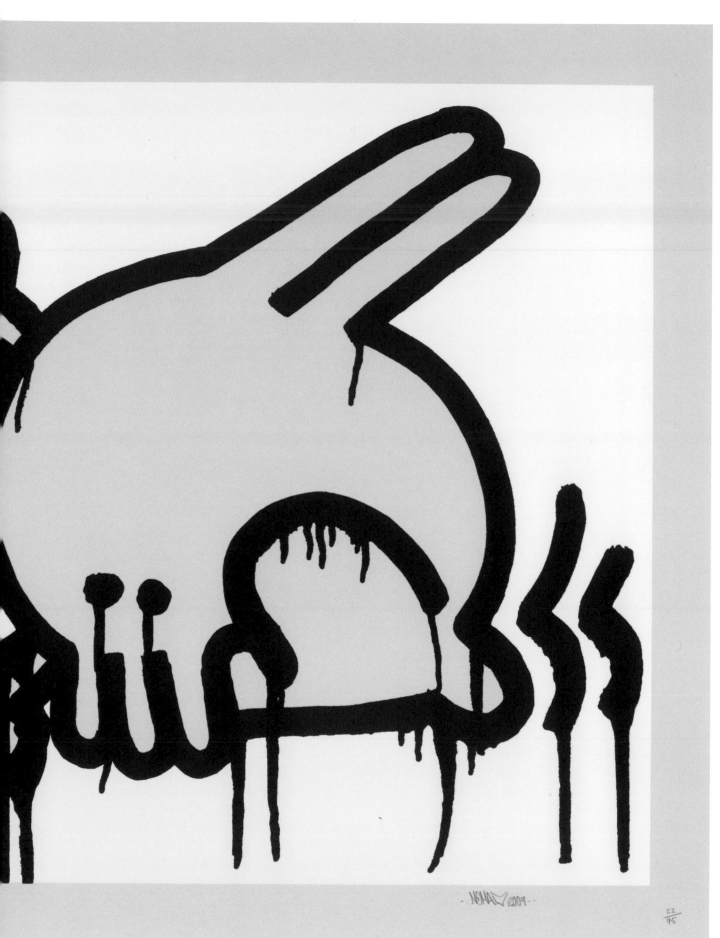

- NOAH 2004 -

22
75

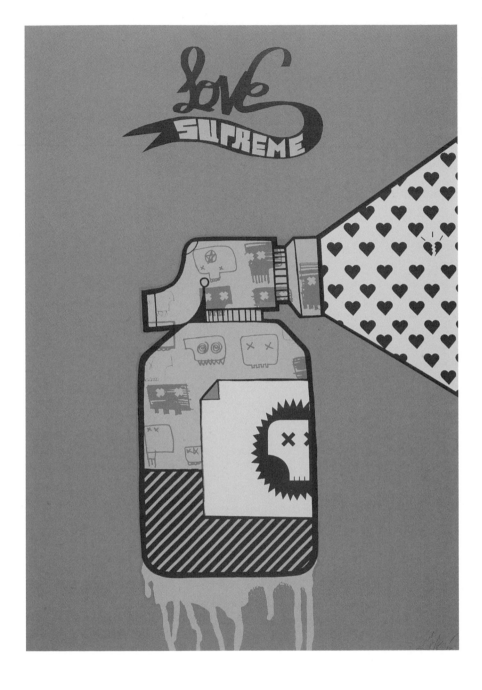

Sickboy
Love Supreme (37/250)
Screen print, 69.8 × 49.9 cm, c.2004
V&A: E.382—2005
Purchased through the Julie and
Robert Breckman Print Fund

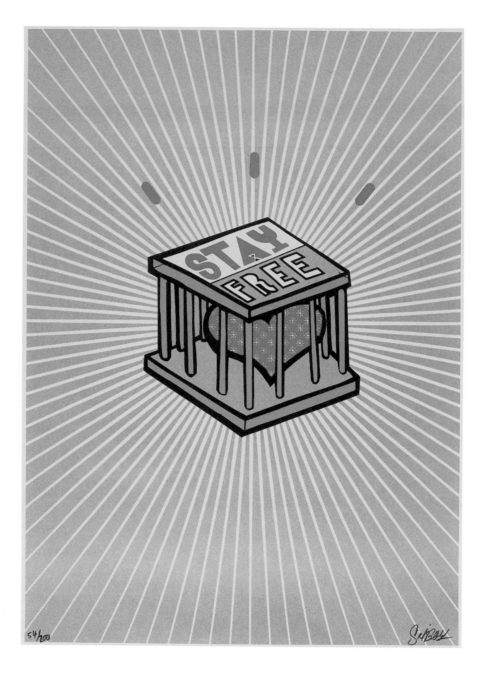

Sickboy
Stay Free (54/200)
Screen print, 70 × 50 cm, c.2008
V&A: E.324—2010

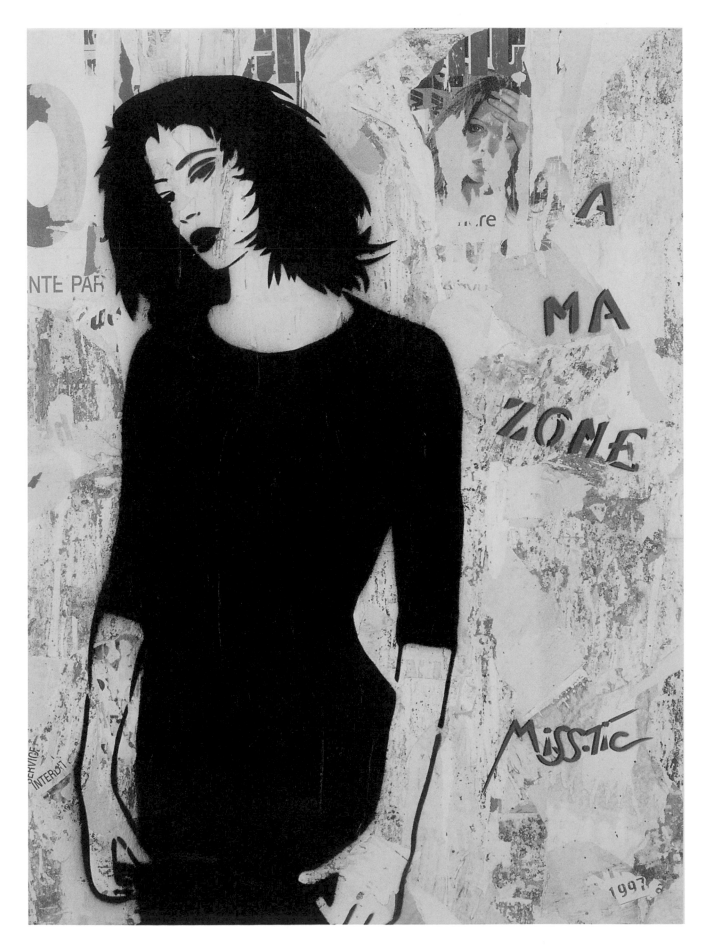

←
Miss Tic
A Ma Zone (10/10)
Screen print
56.3 × 37.6 cm, 2004
V&A: E.274–2005
Purchased through
the Julie and Robert
Breckman Print Fund

↓
Miss Tic
*Nous sommes tous en
situation irrégulière* (1/10)
Stencil print
40 × 60 cm, 2004
V&A: E.275–2005
Purchased through
the Julie and Robert
Breckman Print Fund

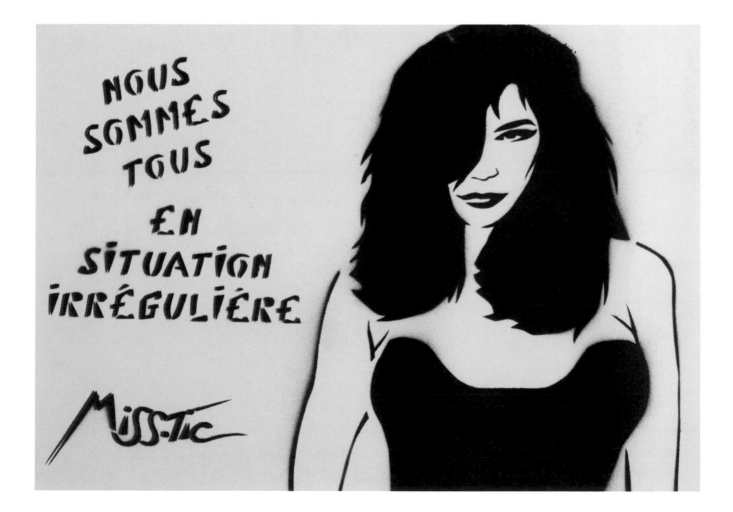

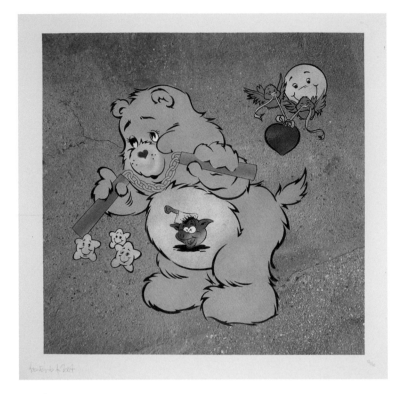

Eine
Scare Bear (36/50)
Lithograph, screen print and spray paint
70 × 70 cm, 2007
V&A: E.492—2009
Gift of the Pure Evil Gallery

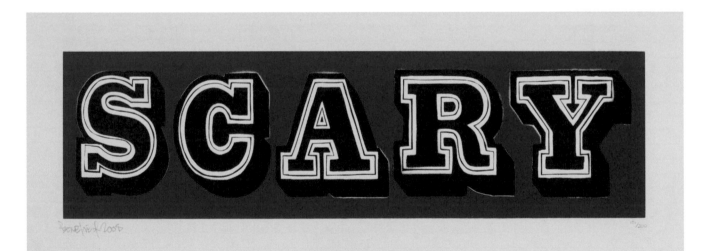

Eine
Scary (101/200)
Hand-pulled screen print
30 × 80 cm, 2008
V&A: E.319—2010

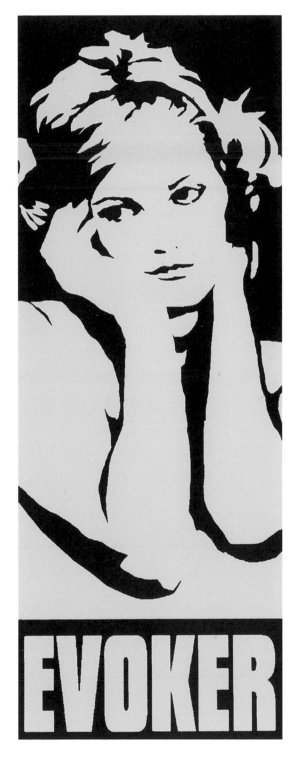

Evoker
Untitled
Sticker, 13.8 × 5 cm, c.2004
V&A: E.319—2005

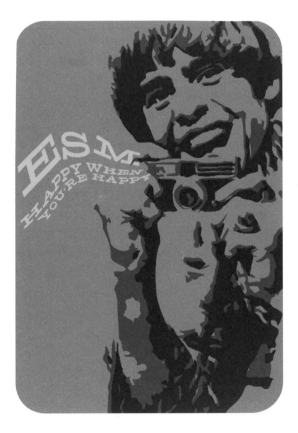

ESM-Artificial
ESM. Happy When You're Happy
Sticker, 9.9 × 6.5 cm, c.2004
V&A: E.324—2005

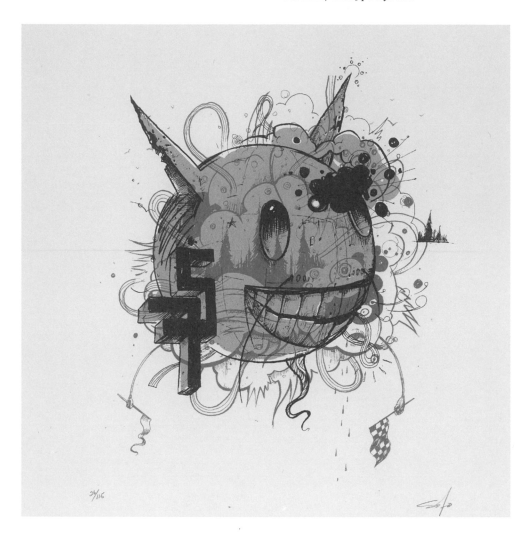

↑
Jeff Soto
Storm Clouds (26/115)
Screen print
40 × 40 cm, c.2009
V&A: E.321–2010

→
D*Face
Feels So Good (20/48)
Screen print
138.5 × 84 cm, 2008
V&A: E.589–2009
Gift of Black Rat Press

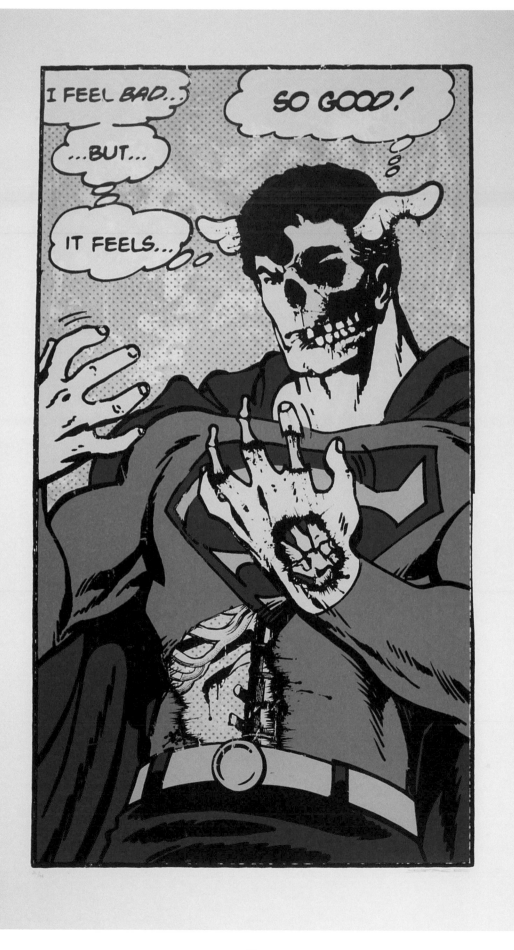

←
Kerry Roper
Detail from *Time Waits for No Man* (30/69)
Screen print
59 × 42 cm, 2010
V&A: E.386—2010
Gift of the artist

Influences
and
Image-making

Street art takes inspiration from a diverse range of sources. Some artists engage with themes and subjects familiar from art history, as in the eloquent portraits produced by Graeme Nimmo and Swoon (pp.86–7, p.78); some draw on stylistic influences, as in Insect's *The Executioner* (p.74), with visual flourishes typical of 1960s psychedelic poster art, which in turn was influenced by Art Nouveau; some produce modified, often humorous versions of existing images, such as the take on Picasso's *Guernica* by Pure Evil (or 'Pablo Picachu' in this case; pp.32–3). Surrealism is popular, as demonstrated by the strange characters populating the work of Jon Burgerman and olive47 among others (pp.66–9, p.64). Skulls often appear in street art, as in Nomad's *Skull Bunny* (p.49), suggesting an interest in *vanitas* paintings, with their symbols of mortality, including dead animals, wilting flowers and rotten meat. Such influences are worn lightly – all elements contributing to the mix like beat samples cut from somebody else's song.

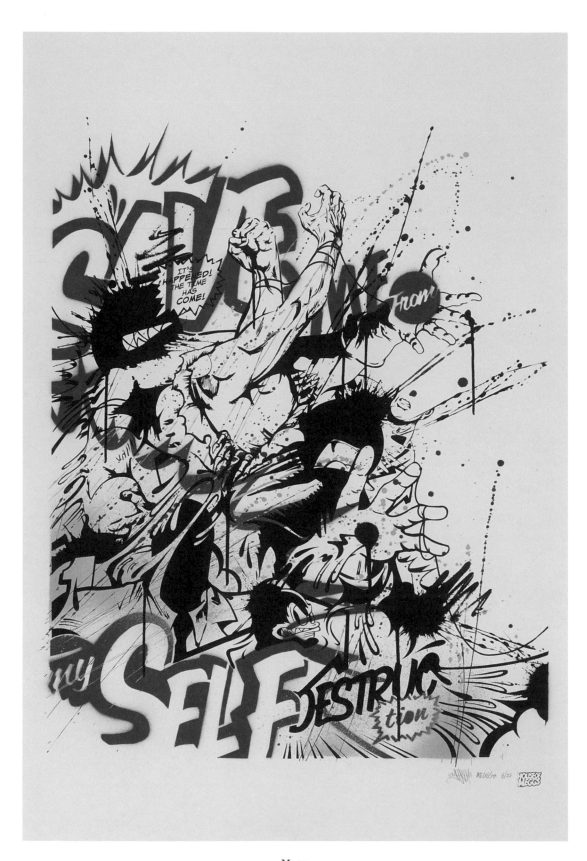

Meggs
Save Me (From Myself) (6/25)
Screen print, 53 × 76 cm, 2007
V&A: E.330–2010

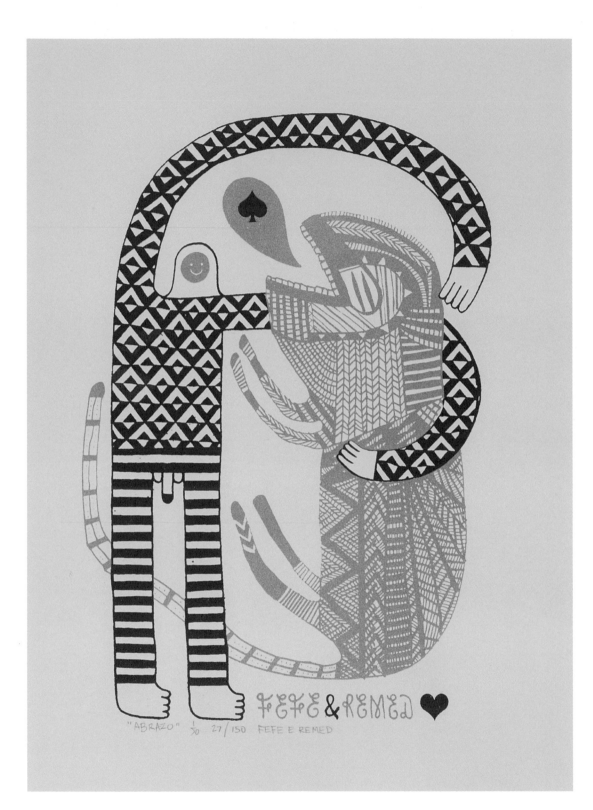

Fefe Talavera and Remed
Abrazo (27/150)
Screen print
45 × 33 cm, 2007
V&A: E.328—2010

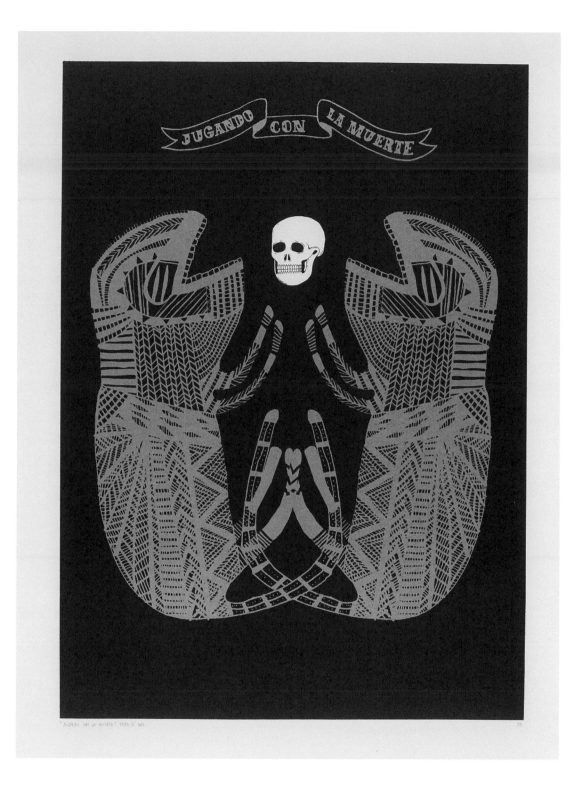

Fefe Talavera
Jugando con la muerte (artist's proof)
Screen print
94 × 66 cm, 2007
V&A: E.329—2010

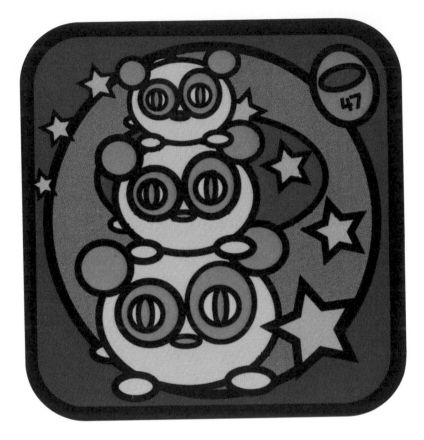

olive47
Untitled
Sticker
7.5 × 7.2 cm, c.2004
V&A: E.321—2005

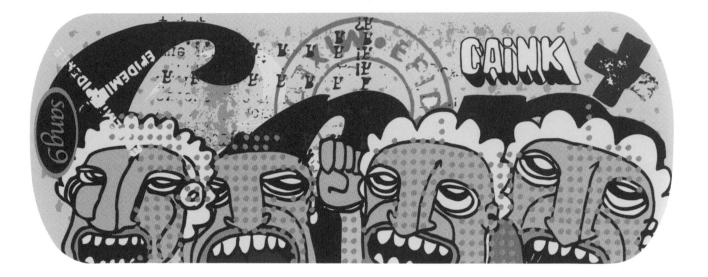

9ème Concept
Heads (Sang 9)
Sticker
7.6 × 19.8 cm, c.2004
V&A: E.326–2005

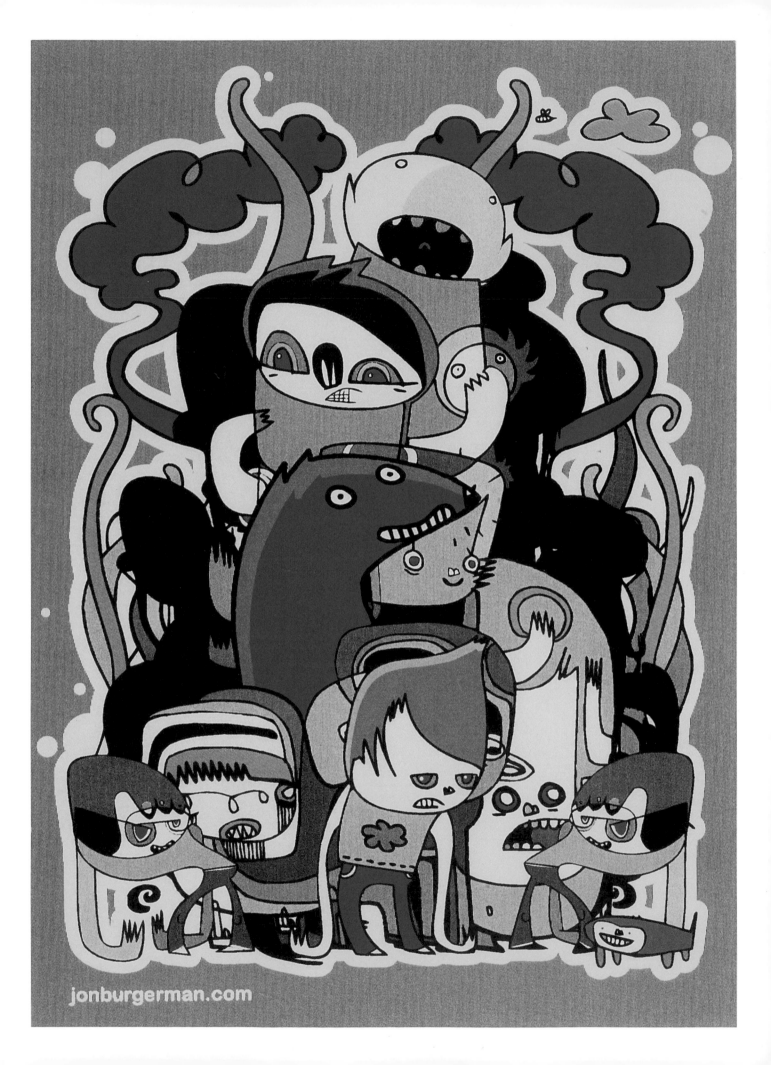

jonburgerman.com

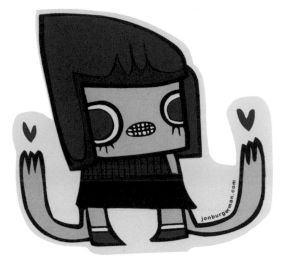

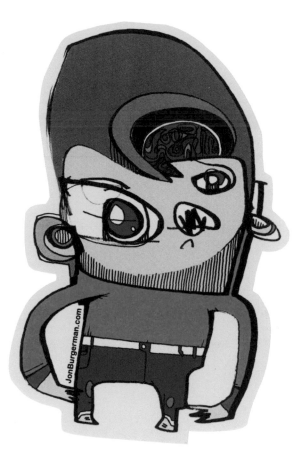

↑
Jon Burgerman
Tiddles MacKenzie
Sticker
6.3 × 6.5 cm, c.2004
V&A: E.318—2005

↗
Jon Burgerman
Untitled
Sticker
10.8 × 6.2 cm, c.2004
V&A: E.322—2005

←
Jon Burgerman
Untitled
Sticker
11.3 × 8 cm, c.2004
V&A: E.317—2005

↓
Jon Burgerman and Sune Ehlers
Hello Duudle
Folded book
10.3 × 150 cm, 2005
National Art Library
Gift of the artist

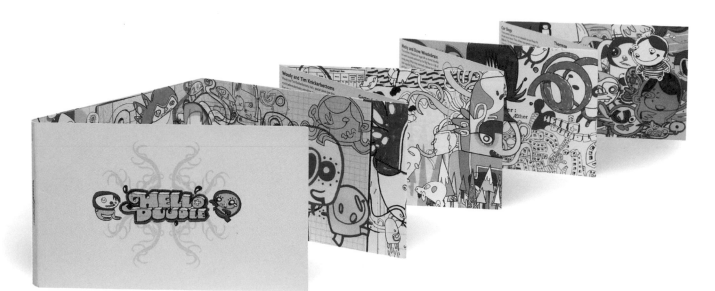

↓ →
Jon Burgerman and Sune Ehlers
Duudleville Tales
Folded book
7.6 × 100 cm, 2004
National Art Library
Gift of the artist

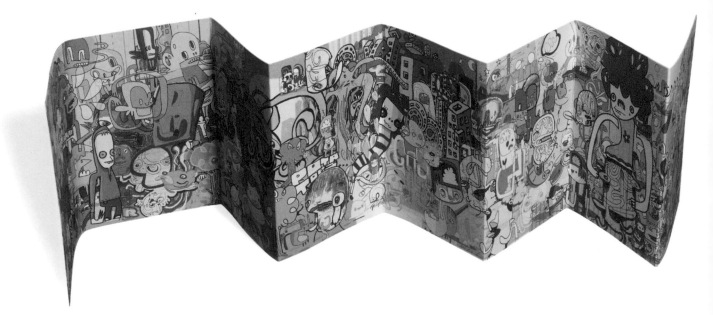

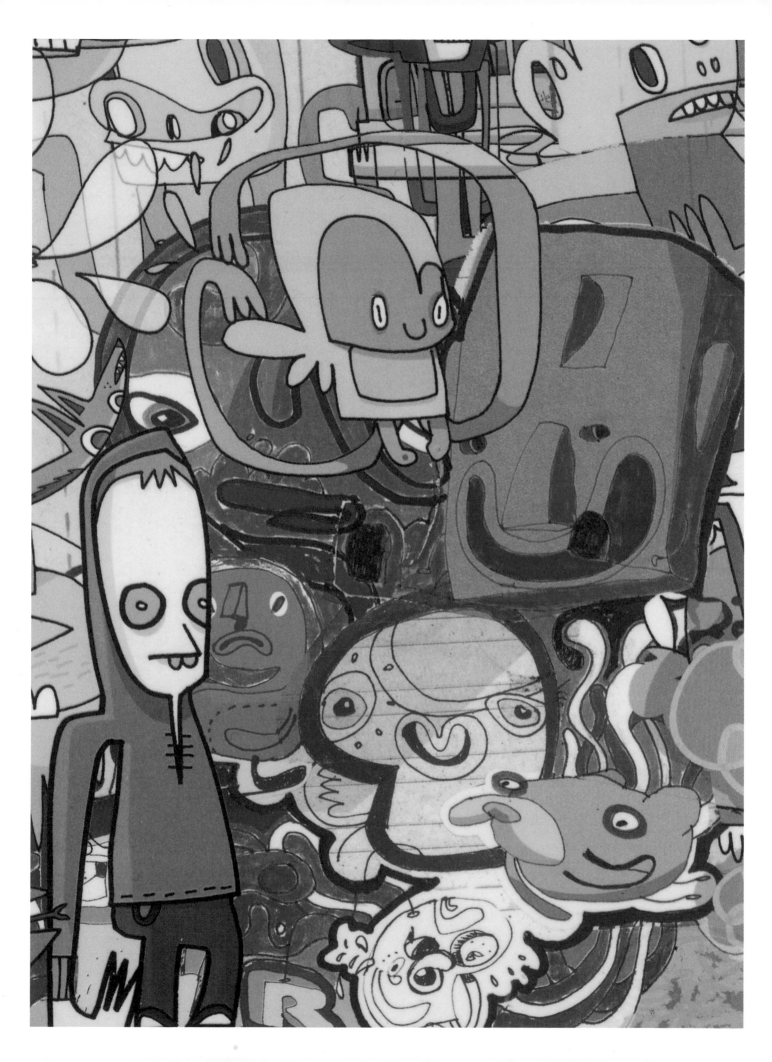

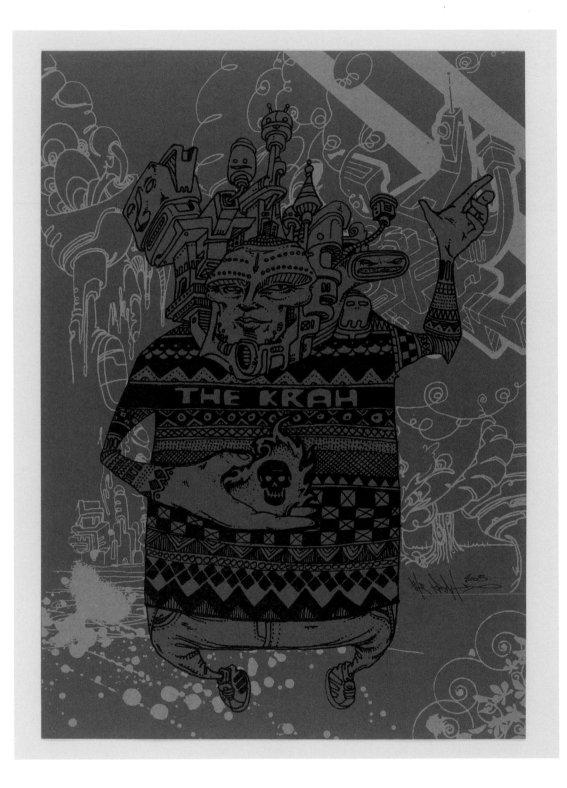

The Krah
The Krah
Screen print, 41.7 × 29.5 cm, 2008
V&A: E.494–2009
Gift of the Pure Evil Gallery

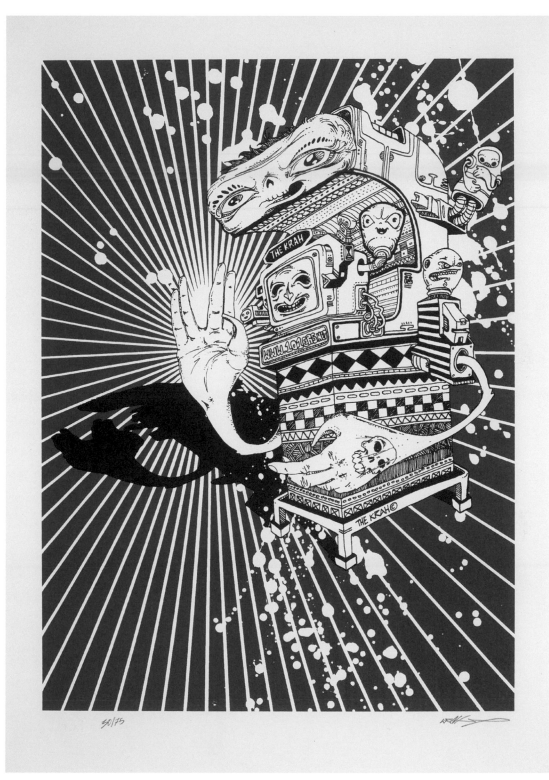

The Krah
Utopia (30/75)
Screen print, 66 × 48 cm, c.2009
V&A: E.493–2009
Gift of the Pure Evil Gallery

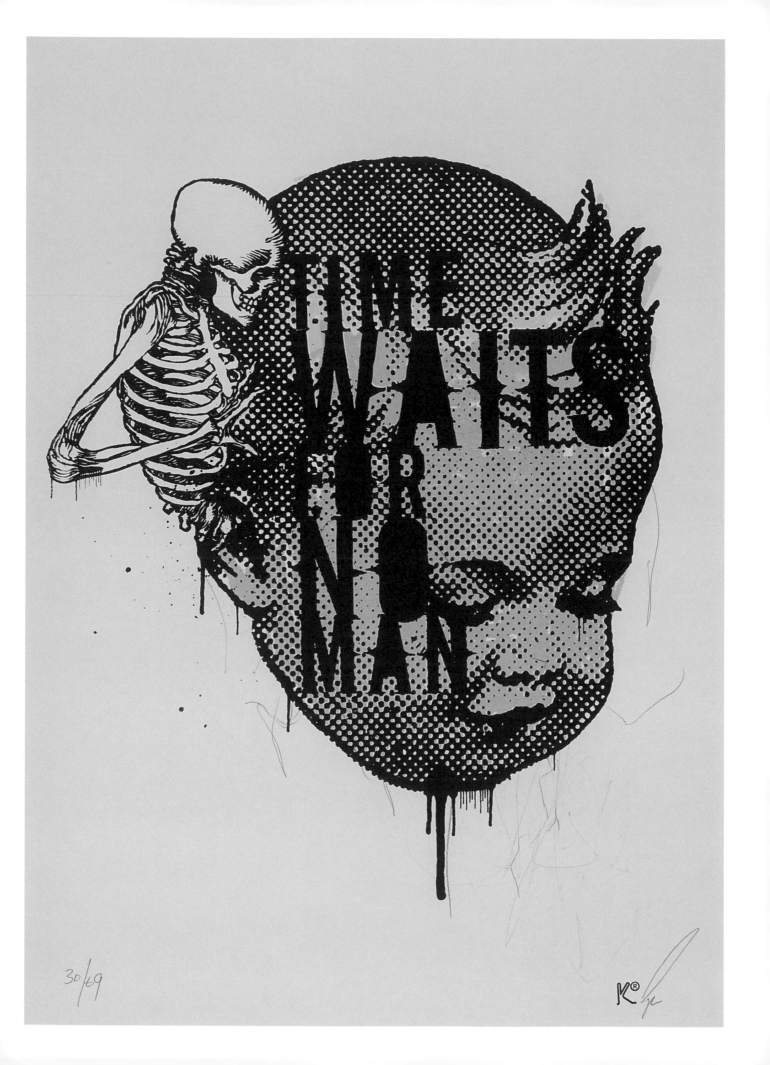

30/49

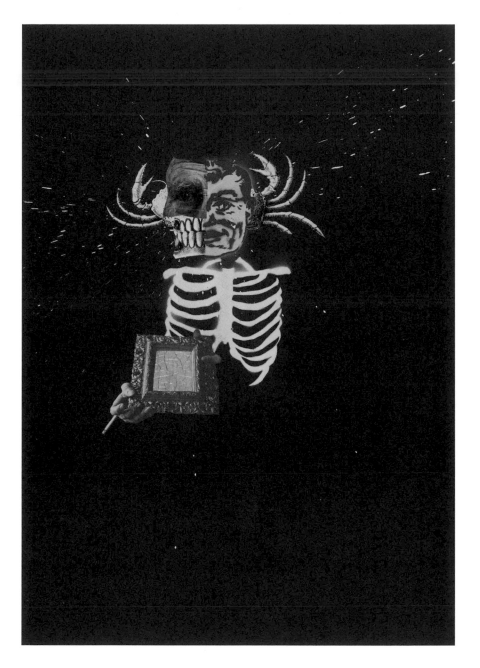

←

Kerry Roper
Time Waits for No Man (30/69)
Screen print
59 × 42 cm, 2010
V&A: E.386—2010
Gift of the artist

↑
Horn Head
Weird Uncle
Collage and spray paint
on paper, 84 × 60 cm, 2009
V&A: E.333—2010

73
96

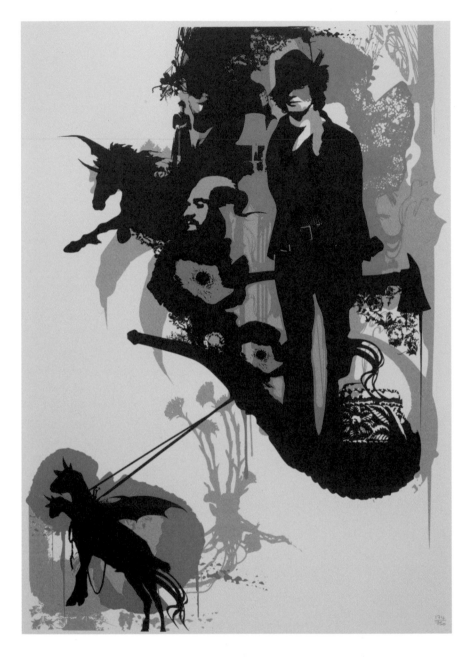

↑
Insect
The Executioner (174/750)
Screen print
69.3 × 49.8 cm, *c*.2004
V&A: E.383–2005
Purchased through
the Julie and Robert
Breckman Print Fund

→
Pinky
Helter Skelter (48/50)
Screen print
50 × 40 cm, *c*.2008
V&A: E.325–2010

48/50

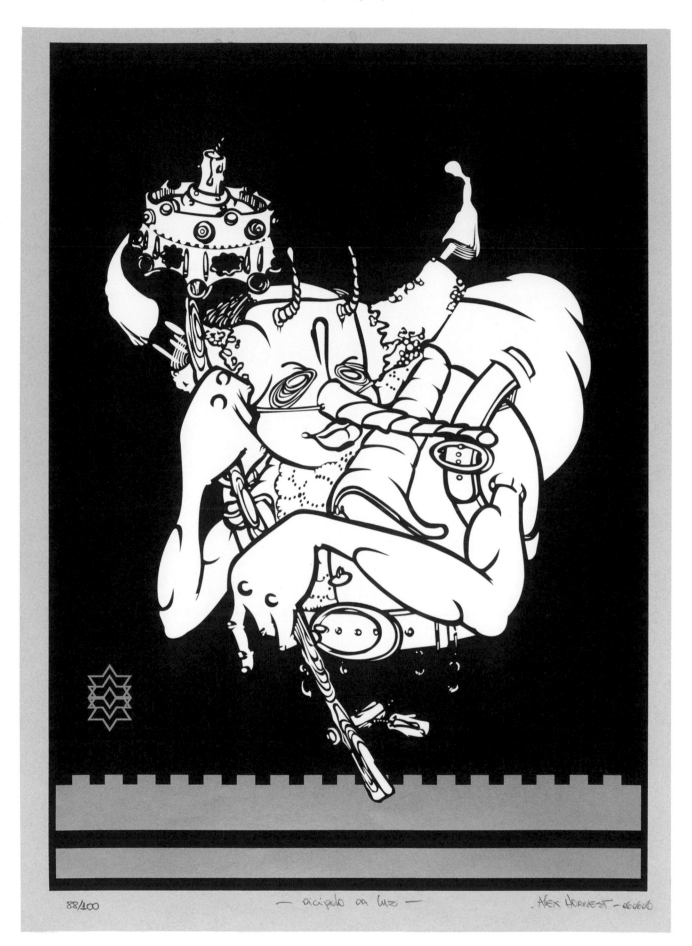

88/100 — discípulo da luz — Alex Hornest - 060600

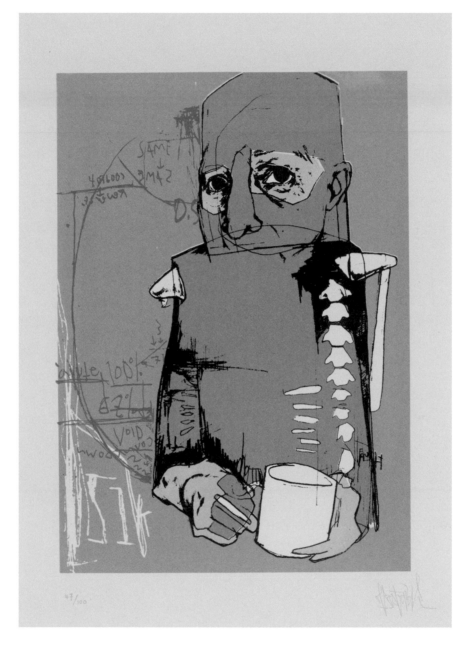

←
Alex Hornest
Discípulo Da Luz (88/100)
Screen print
66 × 48 cm, 2008
V&A: E.331—2010
Gift of the artist

↑
Best Ever
51K (47/100)
Screen print
50.5 × 35.5 cm, c.2009
V&A: E.320—2010

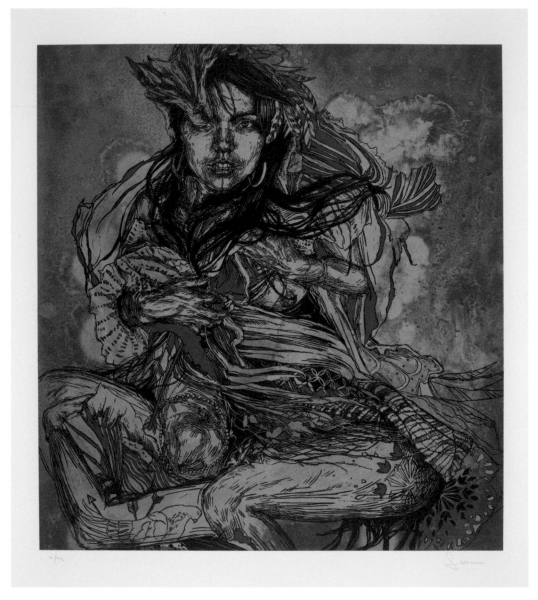

Swoon
Monica (10/75)
Screen print
76 × 70 cm, 2010
V&A: E.437–2010
Gift of Black Rat Press

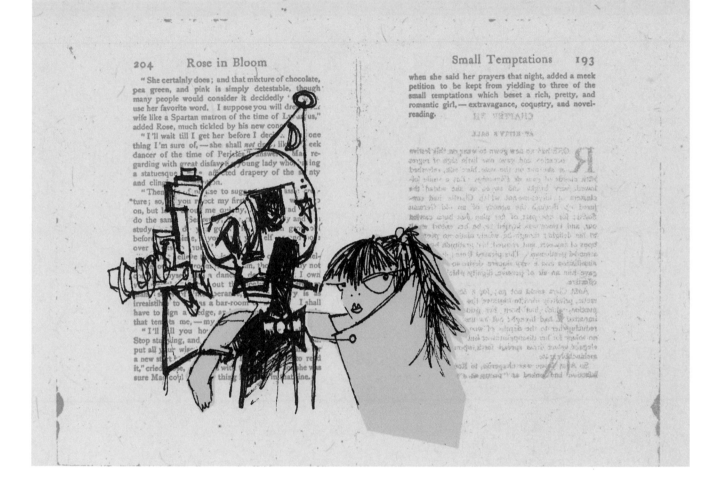

Deadbeat Donny
She Likes Clowns
Screen print
14.7 × 21 cm, 2009
V&A: E.497–2009
Gift of the Pure Evil Gallery

———

City
and
Street

———

The urban environment is the defining element of street art – not only a printing or painting surface, but also a subject in its own right. Some artists address urban living directly: *Periferia Uniforme* by Vhils (p.90) depicts the suburbs surrounding Paris, while Deadbeat Donny produces strange and perhaps alienating cityscapes (pp.82–3). Projeto CHÂ's *Yello São Paulo* (p.91) takes familiar elements of the metropolis and orders them into a pattern that, at first glance, looks purely decorative. Other artists, like Graeme Nimmo, re-create the look of a city wall in an eloquent effort to fuse the traditional subject matter of portraiture with graffiti-referencing expression, complete with paint drips (pp.86–7). Pure Evil's *Frost Fair* (p.85) uses London as its setting and inspiration, but also refers to the act of creating street art with an enormous vampire-fanged rabbit figure scattering the artist's bad-bunny emblems across the city.

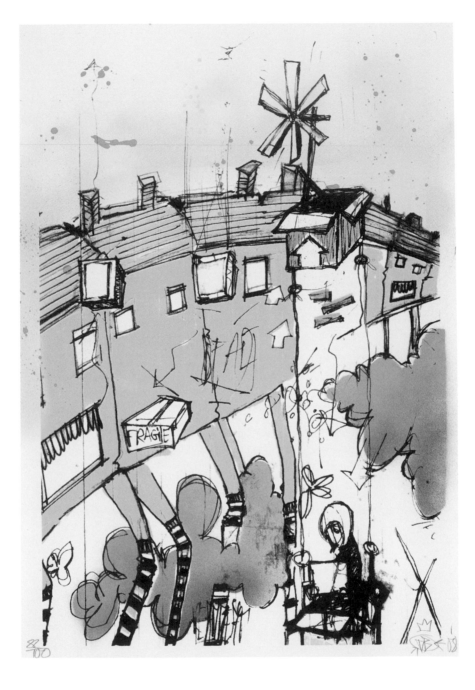

Deadbeat Donny
Deadbeat 1 (88/100)
Screen print
50 × 35 cm, 2008
V&A: E.495—2009
Gift of the Pure Evil Gallery

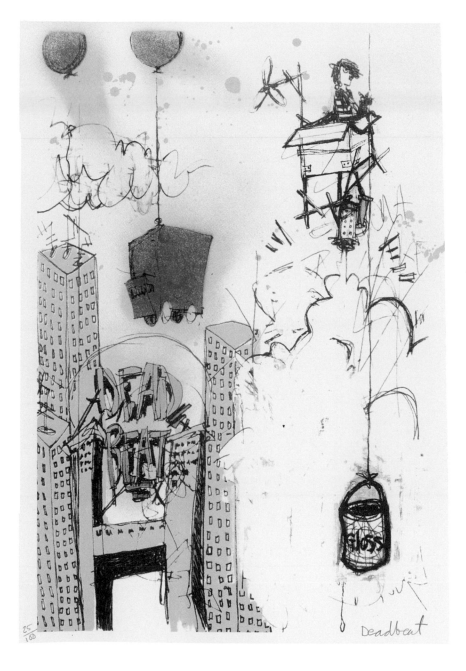

Deadbeat Donny
Deadbeat 2 (25/100)
Screen print
50 × 35 cm, 2008
V&A: E.496—2009
Gift of the Pure Evil Gallery

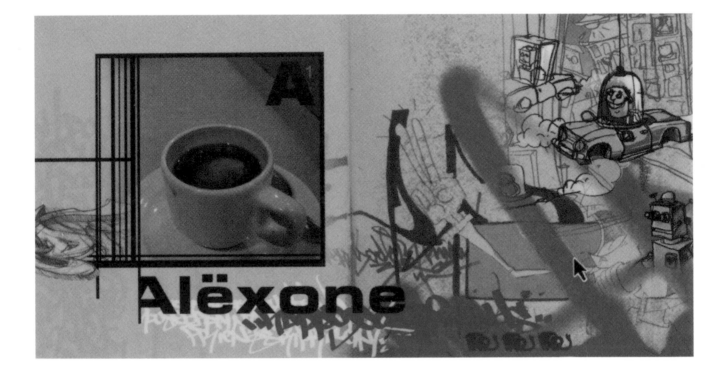

Alëxone
Untitled
Sticker
5.1 × 9.8 cm, c.2004
V&A: E.315—2005

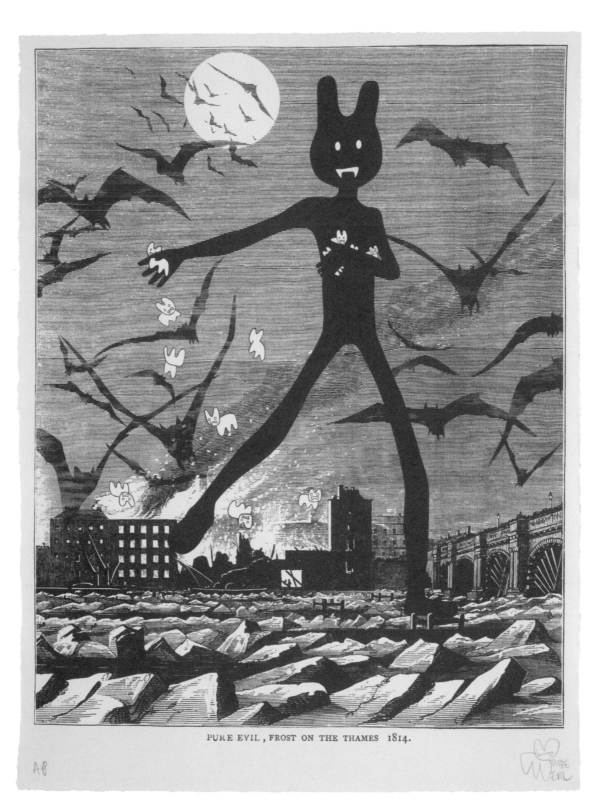

PURE EVIL, FROST ON THE THAMES 1814.

Pure Evil
Frost Fair (artist's proof)
Sepia print
76 × 56.5 cm, c.2008
V&A: E.489–2009
Gift of the Pure
Evil Gallery

Graeme Nimmo
Off the Wall
Etching and spray
paint on paper
70.2 × 59.2 cm, 2004
V&A: E.277–2005
Purchased through
the Julie and Robert
Breckman Print Fund

Graeme Nimmo
Nemo
Etching and spray
paint on paper
86.6 × 86.8 cm, 2004
V&A: E.278—2005
Purchased through
the Julie and Robert
Breckman Print Fund

↑
Dave Kinsey
Untitled
Sticker
10 × 6.8 cm, *c.*2004
V&A: E.323—2005

→
Blu
CMYK **(148/250)**
Screen print
70 x 50 cm, *c.*2009
V&A: E.337—2010

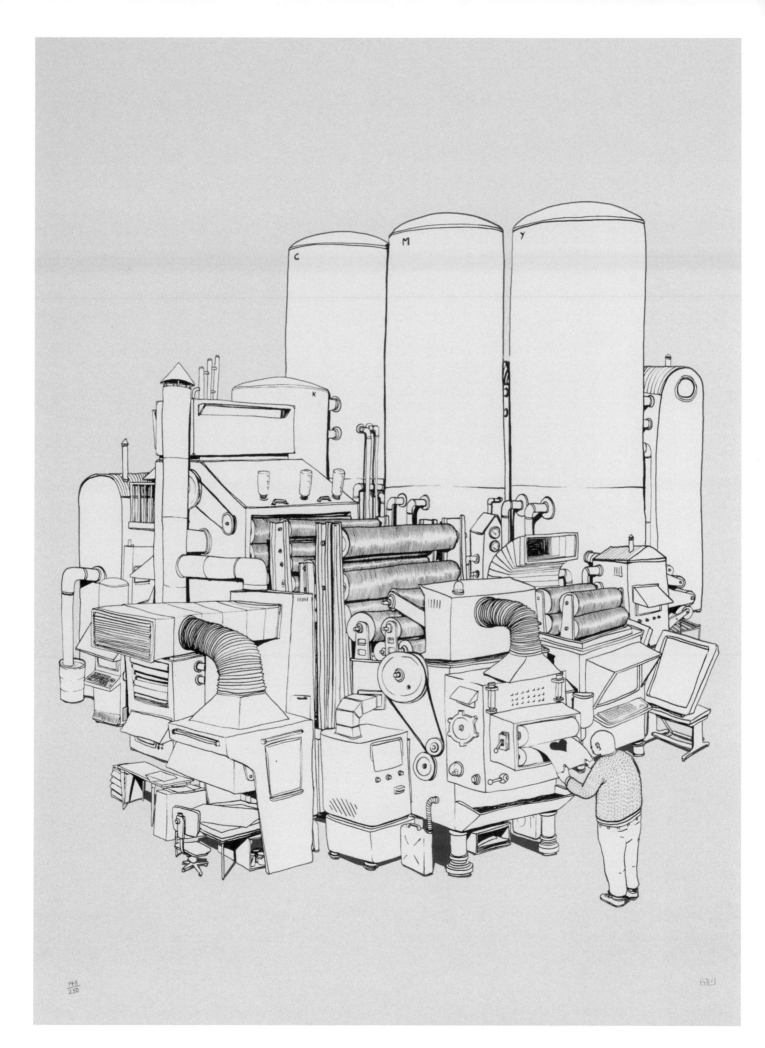

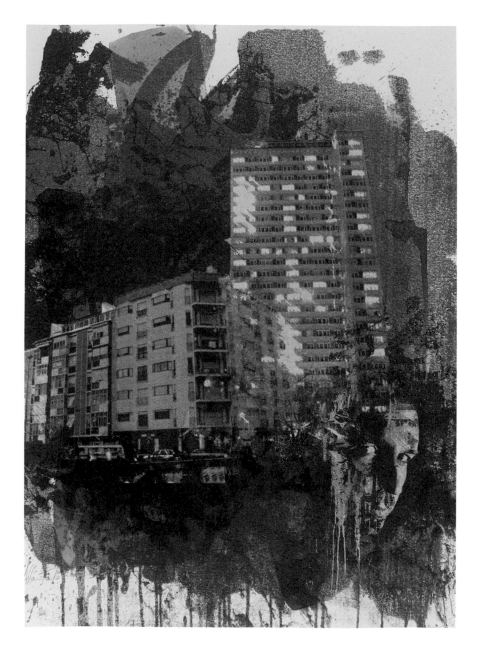

Vhils
Periferia Uniforme (21/200)
Multilayered print using inks,
bleach, screen-print inks and varnish
70 × 50 cm, *c.*2009
V&A: E.334—2010

Projeto CHÂ
Yello São Paulo (63/100)
Screen print
64 × 47 cm, 2007
V&A: E.332—2010

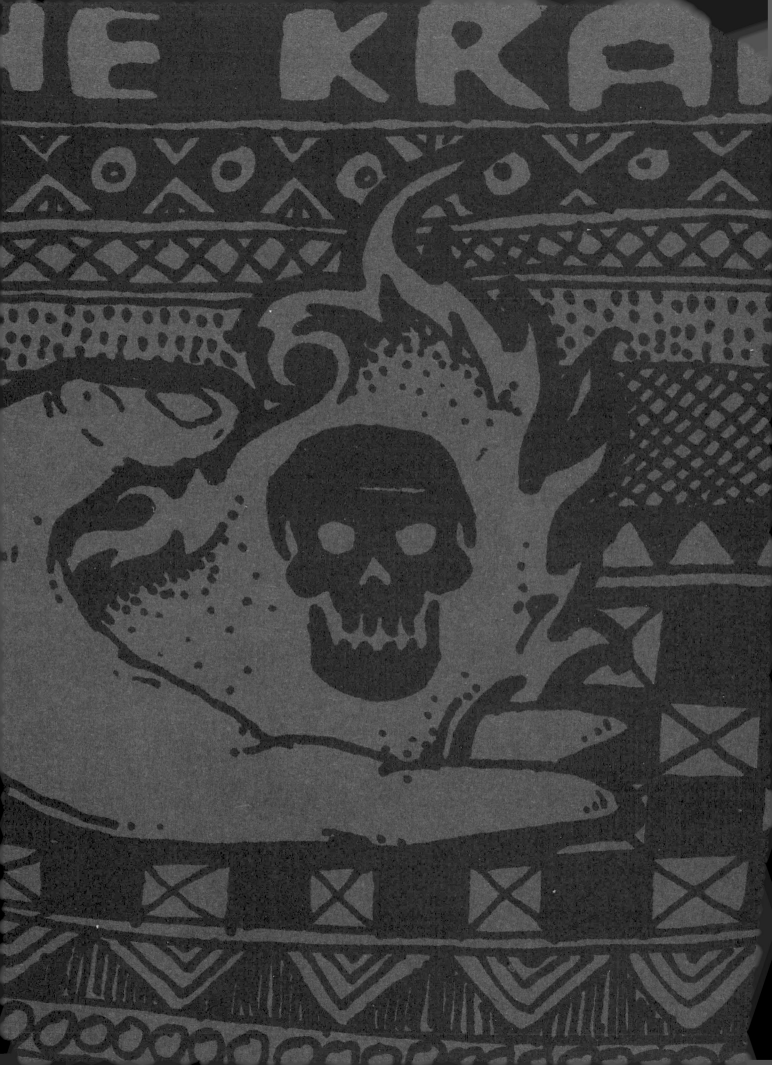

Artists

3-D
3-D, or Robert Del Naja, is best known for his role in the Bristol collective Massive Attack. He has produced record packaging for the group and for other artists including UNKLE. His artwork has strong painterly elements and features a dark palette of colours and figures. Del Naja's career exemplifies the interconnected nature of music and visuals, particularly typical of Bristol's cultural output.
www.myspace.com/robertdelnaja

9ème Concept
The Parisian collective 9ème Concept is founded on the principles 'concept, creation, action'. The artists have a variety of skills, from painting to graphic design, and exhibit in their own gallery space in Paris. They produce books and have received commissions from a range of clients, including Coca-Cola, MTV, Prada and Sony.
www.9eme.net

Alëxone
The Paris-based artist Alëxone established a reputation as a tagger in the 1990s. His work has since become more figurative, populated by colourful characters and layered imagery. His fluid, sometimes grotesque figures have appeared not only on paper and canvas but also on clothes and even cars. Alëxone exhibits internationally and has produced a book, *Came à Yeux* (*Drug for the Eyes*, 2007).
www.alexone.net

Banksy
Banksy began his career in Bristol's graffiti scene in the 1990s. His output varies from stencil graffiti and interventions in museums to painting sections of the Israeli West Bank Barrier. His work is widely collected and exhibited and has been the subject of a feature-length film, *Exit Through the Gift Shop* (2010). Throughout his career, Banksy has continued to produce street stencils, as recognizable as they are irreverent. He has arguably created a new category of artist all his own.
www.banksy.co.uk

Best Ever
Best Ever are two artists whose work has evolved from graffiti writing to a figurative, painterly style influenced by such artists as Francis Bacon. They have collaborated since 2008 and have exhibited internationally. Although their work is removed from the classic language of graffiti in the most obvious visual sense, they continue to employ graffiti techniques and to produce work on the streets.
www.wearebestever.co.uk

Blek Le Rat
Blek Le Rat began producing stencil graffiti in Paris in the early 1980s and has had a significant influence on street art ever since. He first produced images of rats, using a simple cut-out stencil technique. His work often features three-dimensional, shadowy figures that emerge from the wall in black and white. Blek's artworks are exhibited in galleries worldwide even as he continues to work in the urban environment.
http://bleklerat.free.fr

Blu
The Italian street artist Blu is known for his large-scale murals of sometimes unsettling, visceral scenes. His character-based visuals vary from the violent to the political. He has produced work internationally, including commissioned wall paintings in Europe and South America, and has also created animations comprising a series of wall paintings that unravel across concrete in an uninterrupted surreal narrative.
www.blublu.org

Jon Burgerman
Jon Burgerman is a Nottingham-based artist or 'doodler'. His illustrations of friendly alien-like characters appear on many surfaces, from books to walls, canvases and stickers. His commissioned work includes display graphics at the Science Museum in London, and he has exhibited internationally in solo and group exhibitions and in live drawing events.
www.jonburgerman.com

Deadbeat Donny
The illustrations of London-based street-art collective Deadbeat Donny feature a muted colour palette and often depict cityscapes with balloons, retro hi-fi equipment and wonky typography. Exhibited in solo and group exhibitions, their works have a layered, worn-in quality, reminiscent of rain-washed and weather-beaten street paintings.
www.thedeadbeats-ldn.com

D*Face
D*Face is a London-based street artist who founded the Outside Institute, now Stolen Space Gallery, in east London. He has spread his D*Dog and angel-wing symbols far and wide, while producing work in a variety of media and exhibiting internationally. In 2009 he produced a commissioned mural in Pisa, Italy, to commemorate the artist Keith Haring.
www.dface.co.uk

Dscreet
London-based Dscreet is famous for his large-scale owl paintings, executed in striking colours. Now a well-known street-art motif, the owls, with their sinister stares and outsized claws, lie somewhere between friendly cartoons and CCTV paranoia. Dscreet also tags his name in enormous, colourful lettering – anything but discreet. His works have been displayed in gallery exhibitions in the UK and abroad.
www.myspace.com/dscreet

Eine
The London-based graffiti artist Ben Eine is a prolific image-maker, his work encompassing stickers, paintings and even handbag decoration. He is perhaps best known for his giant letters painted on shop shutters in east London, other British cities and abroad. This colourful lettering is a natural progression from graffiti tagging, a meeting point between typography and street art.
www.einesigns.co.uk

ESM-Artificial

The Canadian artist ESM-Artificial takes inspiration from popular culture, celebrities and human behaviour. Familiar images, famous people and sunny slogans populate his often humorous work, which takes a variety of forms, from screen prints to books, and has been exhibited internationally. *www.esm-artificial.com*

Evoker

Based in Boston, Evoker produces stickers and illustrative work both for clients and on the streets. His output is firmly placed within skateboard culture and he works as an art director for a skateboard wheel company. Evoker has been commissioned to paint murals by a number of companies, including Adidas and Nickelodeon. *www.evokerone.com*

Shepard Fairey

The American graphic artist Shepard Fairey's *Obey Giant* campaign began in 1989. A true phenomenon of viral communication, the spread of *Obey Giant* shows how people read and spread images in multiple ways, outside the avenues of branding and advertising. Fairey exhibits internationally but continues to practise street art where possible. *http://obeygiant.com*

Jamie Hewlett

An established cartoonist and illustrator, Jamie Hewlett is co-creator of both the comic strip *Tank Girl* and, in collaboration with the musician Damon Albarn, the virtual band Gorillaz. His distinctive style has lent itself to ambitious projects: he created visuals for the BBC's Beijing Olympics coverage in 2008 and designed the opera *Monkey: Journey to the West* in 2007. *www.jamiehewlett.co.uk*

Alex Hornest

Based in São Paulo, Alex Hornest is an important figure in the Brazilian street-art scene. His output encompasses painting, sculpture and prints, and is exhibited and collected internationally. Vivid characters populate his work, which combines comic-book expression with surreal touches. He has 72 different signatures, one for each of his working concepts, Onesto being his oldest signature, used for portraits of strange creatures. *www.alexhornest.com*

Horn Head

The British street artist Horn Head creates sinister, macabre collages of skulls and skeletons, deer horns and grimacing figures. His work has been included in group exhibitions, and he took part in the Cans Festival in 2008, when street artists created a large-scale graffiti installation in a tunnel by Waterloo Station in central London.

Insect

Insect, a London-based design group, produces dream-like visuals that are strikingly contemporary but with touches of the psychedelic, the gothic and the surreal. The group's graphic art has been included in international exhibitions and they have received commissions for advertising campaigns from companies such as Adidas. Insect's versatile output also encompasses illustration and branding. *www.paulinsect.com*

Dave Kinsey

Dave Kinsey attended the Art Institute of Pittsburgh and the Art Institute of Atlanta before establishing himself as a designer and artist based in Los Angeles. His striking graphic work encompasses a range of media. He has lectured and exhibited worldwide, including a 2004 show at Urbis in Manchester, UK, and he founded the BLK/MRKT Gallery in LA in 2001. *www.kinseyvisual.com*

The Krah

The Krah, brought up in Athens, works and exhibits globally. He began his career in the 1990s by painting on the streets. Since then, his practice has expanded to digital art and commissions produced in his fluid, expressive style. He has taken part in exhibitions internationally, including Art Basel in Miami, the Cans Festival in London and various group shows. *http://thekrah.yokaboo.com*

Meggs

Meggs, a graphic artist based in Melbourne, produces stencil graffiti and paste-ups – artworks on paper pasted directly to the wall – as well as commissioned graphic work. His internationally exhibited output is influenced by pop culture and makes reference to comics, science fiction and toys. The characters that appear in his images juxtapose good and bad, his heroes and villains typical of cartoons and cinema. *www.houseofmeggs.com*

Miss Tic

Miss Tic is a graffiti artist based in Paris. She has been making street art since the early 1980s and is known for her stencil graffiti, which often depicts fierce, beautiful women alongside slogans or word plays. Although she now exhibits and sells her works in commercial galleries, she continues to produce street art in the urban environment at night. Her work is often very personal, but also touches on feminist and political themes. *www.missticinparis.com*

Graeme Nimmo

Graeme Nimmo graduated from the Glasgow School of Art in 2008. His work has evolved from street-art-influenced paintings and prints to digital imagery and film. His portrait prints combine etching with spray paint, updating the traditional genre of portraiture with a contemporary visual expression that celebrates the simple beauty of the human figure with 'rough-around-the-edges' visuals. *http://graemenimmo.snappages.com*

Nomad

Berlin-based Nomad is an international name within the street-art community. His work, now widely collected, has evolved from skate-culture beginnings to encompass sculpture and figurative works on canvas. His output, varying between different media and ranging in visual motifs from bunnies to clowns, is notable for its undercurrents of humour and spontaneity. *www.myspace.com/nomad_yesmad*

olive47

The American artist olive47 is based in London. Her brightly coloured, naive graphic style belies her background in art history and fine art. Her work is populated by robots, cupcakes and pandas, occasionally monstrous but always good-humoured. She produces paintings, three-dimensional objects and screen prints, while also designing websites and taking on commissioned work. *www.olive47.com*

Pinky

Pinky is a Brighton-based artist whose work encompasses graffiti, painting, prints and cut paper. He exhibits internationally and has received commissions from companies including Dior, Maharishi and the BBC. His work often focuses on patterns, creating imagery out of typography and jolly characters to produce a brightly coloured visual language that could be described as contemporary psychedelia. *www.pinkyvision.com*

Projeto CHÂ

Projeto CHÂ is based in Brazil. He is an active member of the São Paulo graffiti scene and spreads his prints and stickers throughout the city. Projeto CHÂ's vibrant, striking work is both of and about its urban environment, creating a dialogue between art and the street through visual interventions. *www.fotolog.com/projeto_cha*

Pure Evil

Pure Evil exemplifies the freedom that street-art practice can offer: as both street painter and gallerist, he exhibits his own and other artists' works while exploring different methods of image-making. His vampiric bunny motif, often executed in neon spray paint, has spawned a diverse body of work that draws on a wide range of references and media. *www.pureevilclothing.com*

Remed

Remed began creating street art in his native Lille in the mid-1990s. He has exhibited internationally and created murals in locations across Europe and the United States. His images are built out of graphic patterns, fluid figures, symbols and typography. His use of striking colours and clean lines echoes art from the past, yet creates an unmistakably contemporary impression. *http://remed.es*

Kerry Roper

Kerry Roper is an established graphic designer and illustrator whose work has been exhibited internationally. He has designed record sleeves and provided images for advertising campaigns, and his illustrations have featured in books and magazines. His strong graphic approach, with vivid colours and bold lines, has occasional flamboyant, almost Baroque touches. *www.youarebeautiful.co.uk*

Scorn

Scorn is a street artist based in Thailand. His work appears on the streets of Bangkok and has been exhibited internationally, including group shows in British galleries. Bangkok has an emerging, vibrant street-art scene, with a close-knit community of graffiti artists creating diverse work. *www.souledoutstudios.co.uk*

Sickboy

The British street artist Sickboy sells his paintings and prints online and through galleries, yet he continues to paint on the streets. His chubby temple or minaret symbol, usually painted in yellow and red, is a well-established street-art motif. His work is populated by logos and slogans executed in bright colours with cheery good humour. *www.thesickboy.com*

Jeff Soto

Based in California, Jeff Soto is known for distinct visuals that draw influences from graffiti, toys and skate culture. His motifs include robotic figures, skulls and dark clouds, all painted in striking detail. He has exhibited widely in solo and group shows in the United States and Europe. *www.jeffsoto.com*

Sweet Toof

The British artist Sweet Toof's motif of teeth and gums is a familiar sight in east London. His fine-art background is evident in his skilfully produced prints. Although he now sells work in a variety of media through galleries, he continues to paint on the streets at night. *http://sweettoof.com*

Swoon

New York-based Swoon has a unique poetic visual language. She has moved from figurative paintings to stencil works and paste-ups, her fine-art background forming the visual substance of her street work. As well as exhibiting in galleries and taking part in shows internationally, she has also created participative, three-dimensional work: a 2009 project saw her building floating sculptures from waste, one of which sailed to the Venice Biennale. *www.deitch.com/artists/sub.php?artistId=31*

Fefe Talavera

Fefe Talavera is a Mexican–Brazilian artist based in São Paulo – a city known for its energetic street-art scene. Her striking, vibrant paintings and prints have echoes of tribal and South American visuals. Beasts and monsters populate her work as symbols of human emotions, including anger and desire. She has a second home in Spain and has exhibited internationally. *http://fefetalavera.blogspot.com*

Vhils

Born in Portugal, Vhils has quickly established himself as a dynamic street artist. He has exhibited internationally and taken part in group shows including the art and theatre installation *Tunnel 228* in London in 2009. His work draws inspiration from the city, approaching street-art practice as a method of transforming the urban environment. He utilizes existing surfaces and peeling layers to create striking large-scale portraiture. *http://alexandrefarto.com*

Websites

www.4wall.co.uk
www.artofthestate.co.uk
www.bestshopever.com
www.blackratpress.co.uk
www.duncancumming.co.uk
www.invisiblemadevisible.co.uk
www.lazinc.com
www.myspace.com/stelladore
www.picturesofwalls.com
www.picturesonwalls.com
www.sartorialart.com
www.stolenspace.com
www.thebricklanegallery.com
www.ukstreetart.co.uk
www.urbanangel.com
www.woostercollective.com

Picture Credits

© 3-D. Courtesy of 3-D and Pictures on Walls *37*
© 9ème Concept. Courtesy of 9ème concept *65*
© Alëxone. Courtesy of Alëxone *84*
Courtesy of Art of the State *6, 8, 15*
© Banksy. Courtesy of Banksy and Pictures on Walls *4, 21, 22–3, 24*
© Best/Ever. Courtesy of Best Ever *77*
© Blek Le Rat. Courtesy of Blek Le Rat *34*
© Blu. Courtesy of Blu and Pictures on Walls *36, 80, 89*
© Jon Burgerman. Courtesy of Jon Burgerman *66, 67, 68, 69*
© Deadbeat Donny. Courtesy of Deadbeat Donny and the Pure Evil Gallery *79, 82, 83*
© D*Face. Courtesy of D*Face *2, 57*
© Dscreet. Courtesy of Dscreet and the Pure Evil Gallery *17, 46–7*
Courtesy of Duncan Cumming *10*
© Eine. Courtesy of Eine *38, 54 (bottom)*

© Eine. Courtesy of Eine and the Pure Evil Gallery *54 (top)*
© ESM-Artificial. Courtesy of ESM-Artificial *55 (right)*
© Evoker. Courtesy of Evoker *55 (left)*
© Shepard Fairey *42, 43, 44, 45*
© Jamie Hewlett. Courtesy of Jamie Hewlett and Pictures on Walls *26–7*
© Alex Hornest. Courtesy of Alex Hornest and the Pure Evil Gallery *76*
© Horn Head. Courtesy of Horn Head and the Pure Evil Gallery *73*
© Insect. Courtesy of Insect and Pictures on Walls *74*
© Dave Kinsey. Courtesy of Dave Kinsey *88*
© The Krah. Courtesy of The Krah and the Pure Evil Gallery *70, 71, 92*
© Meggs. Courtesy of Meggs and the Pure Evil Gallery *60, 61*
© Miss Tic. Courtesy of Miss Tic *52, 53*
© Graeme Nimmo. Courtesy of Graeme Nimmo *86, 87*

© Nomad. Courtesy of Nomad and Pictures on Walls *48–9*
© olive47. Courtesy of olive47 *64*
© Pinky. Courtesy of Pinky *75*
© Projeto CHÂ. Courtesy of Projeto CHÂ and the Pure Evil Gallery *91*
© Pure Evil. Courtesy of Pure Evil and the Pure Evil Gallery *28, 29, 30, 31, 32–3, 85*
© Kerry Roper. Courtesy of Kerry Roper *18, 35, 58, 72*
© Scorn. Courtesy of Scorn *25*
© Sickboy, www.thesickboy.com / Published by Pictures on Walls *50*
© Sickboy. Courtesy of Sickboy *51*
© Jeff Soto. Courtesy of Jeff Soto *56*
© Sweet Toof. Courtesy of Sweet Toof *40, 41*
© Swoon. Courtesy of Black Rat Press *78*
© Fefe Talavera and Remed. Courtesy of Fefe Talavera, Remed and the Pure Evil Gallery *62*
© Fefe Talavera. Courtesy of Fefe Talavera and the Pure Evil Gallery *63*
© Vhils. Courtesy of Vhils and Pictures on Walls *90*